The Art of
Sketching

A STEP-BY-STEP GUIDE

The Art of Sketching

A STEP-BY-STEP GUIDE

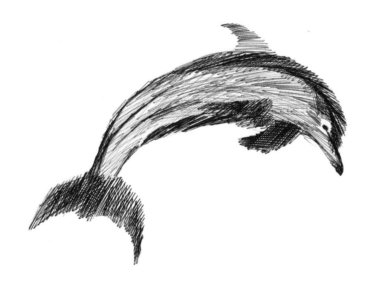

Vivienne Coleman

ARCTURUS

Dedication

To the best: hubby Chris; Pip, Ted and my Dad.

Acknowledgements

My grateful thanks to Arcturus Publishing, Ella Fern and Diana Vowles.
Kind thanks to photographer Paul Rollison ('Observing' chimp photo); Helen Browning (OBE)
Eastbrook Farm organic piglets, Wiltshire; and Paula Ensign (artist and devisor of perspective puzzles,
Washington, USA).
A huge thank you to those who allowed me to base drawings on themselves or their animals
(unknowingly or otherwise!): Jennifer Roberts, Annette Gibbons (OBE) and Paul Gibbons, Chrissie
Wylie, Rachel, Bernice Young, Kate and Jonathan Mowday, Bo (my niece's horse), Tigger (my sister's
cat), Mist (John Malley's border collie), and Sheba the dog.
Special thanks for everyone's support, positivity and kindness especially: Ben Jones (personal trainer),
Janet Wrathall (Naturopath), Mo Colohan (Unique Solutions), David Jeffries (Ministry of Doing), Viridian
Gallery Keswick, Brian Campbell and the Fountain Gallery Wigton, and all at 'Crafts of the North'!
Finally, thank you to all my wonderful customers and students, who continue to inspire me.
www.pencil-drawing.co.uk

ARCTURUS

This edition published in 2018 by Arcturus Publishing Limited
26/27 Bickels Yard, 151–153 Bermondsey Street,
London SE1 3HA

ISBN: 978-1-78828-677-0
AD006081UK

Printed in China

CONTENTS

INTRODUCTION 6

CHAPTER 1: GETTING STARTED 8
Basic materials 10
Basic marks: lines 14
Basic marks: light and dark 15
Basic marks: shapes 17
Volume 18
Practical considerations 20

CHAPTER 2: FIRST SKETCHES 22
Still life 24
Still lifes in simple shapes 25
Shapes and shadows 31
Perspective 33
Proportions 38
Still life: fruit 39
Still life: flowers 43
Still life: chairs 45
Interiors 47

CHAPTER 3: SKETCHING THE OUTDOORS 50
Choosing your subject and taking the plunge 52
Through the window 53
The garden 56
Vegetation 59
Landmarks 61
Skylines and skyscapes 62
Landscapes 63

CHAPTER 4: ANIMALS 70
Where to begin 72
Small animals 73
Aquatic animals 74
Birds 76
Domesticated animals 78
Pets 82
Wild animals 86
Capturing motion 88
Test your observational skills 89

CHAPTER 5: PEOPLE 90
Easy stuff 92
Proportions 94
Expressions 97
Movement 100
Groups of people 101
Portraits 102

CHAPTER 6: URBAN SKETCHING 110
Skylines 112
Street scenes 113
Buildings 119
Transport and journeys 122
The changing seasons 126

Summary 127

INDEX 128

Introduction

If you would like to start sketching, or to improve some sketching skills you have already acquired, then this is the book for you. It shows you in simple steps how to record the world around you in quick sketches – a kind of visual diary in which you can capture special moments on paper.

Whatever your sketching preference, be it portraits, urban scenes, still life, animals or landscapes, this book will help you to explore your own style and guide you through a variety of subjects in easy, confidence-building steps.

It couldn't be easier – there's no need to worry if you think you cannot sketch, or are nervous about trying because of a previous bad experience. If you feel a bit guilty about making time for a new leisure pursuit, rest assured that most of the examples are designed to be completed in minutes.

If you like, you can spend just five or ten minutes each day practising your sketching skills – over coffee or lunch, on the bus or train, or on time-out relaxing at home or on holiday. You'll discover that your sketching will vastly improve with practice and that your life experiences will add richness and quality to your work.

A sketch can be described as a rough drawing, general outline, or brief idea to depict a subject of interest. Sketches are looser, freer and more individual works of art than drawings, and are often conceptual and quickly rendered so accuracy is not always essential, or even achievable! Rather, sketches capture a fleeting impression, a mood, or a key feature of a subject. They can also be preparations for a more formal or detailed drawing or painting.

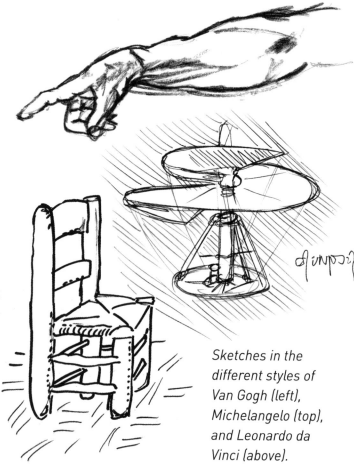

Sketches in the different styles of Van Gogh (left), Michelangelo (top), and Leonardo da Vinci (above).

We are all different so naturally sketch in different ways, and you might be pleased to learn that there is no right or wrong way to sketch. Even famous sketchers had their own style, for example, Leonardo da Vinci (1452–1519), Michelangelo (1475–1564), and Vincent Van Gogh (1853–1890). If you like, you can research their work to discover more about them and be even more inspired.

This book includes everything from basic materials and where to start to more advanced subjects and techniques. You'll find you'll be able to sketch anything, anywhere, at any time!

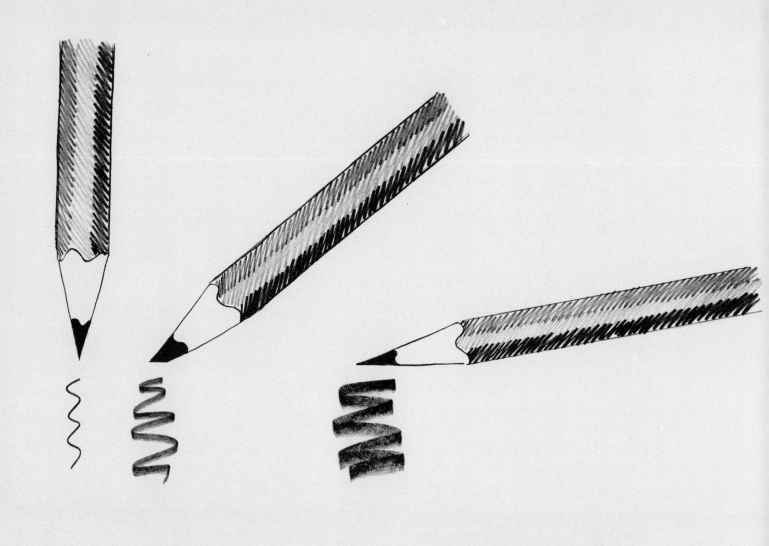
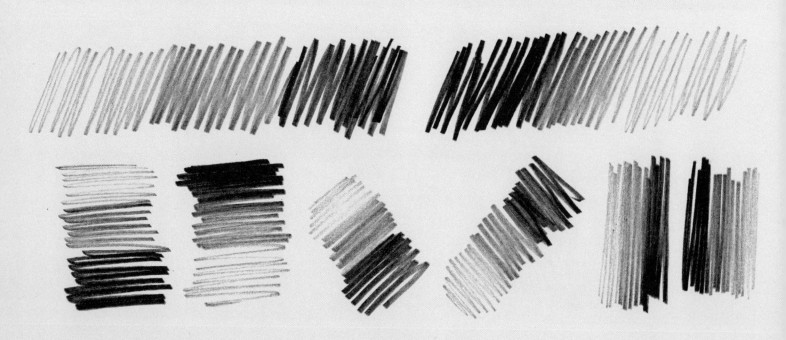

Chapter 1
GETTING STARTED

In this chapter we shall look at the basic things you'll need to start sketching and how you'll make those first marks on paper. The aim is to keep things easy and simple. Don't worry if you're a complete beginner, because the exercises will take you from first steps to competent sketching in easy stages with plenty of examples to try along the way.

To start with, we'll look at sketching materials such as pencil, charcoal, graphite and pen and how you can use these to create various effects on the page. As you learn different techniques you'll be given the opportunity to experiment so that you can discover your favourite ways of working and develop your own style.

We'll look at lines and shapes and how to bring these to life with light and dark tones to create volume and realism, and you'll also begin to look at things in a new way.

Many exercises are designed to be completed in just a few minutes, so you can practise for only a little while every day if that suits you.

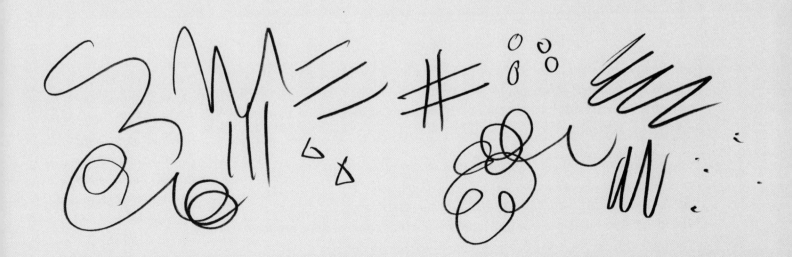

Basic materials

You may be surprised to learn how few materials you really need to begin sketching – in fact, just a pencil or pen and some paper! Of course, these are available in different forms, so we'll look at a range of these basic sketching materials which are lightweight, relatively inexpensive and easy to obtain so it's easy for you to sketch wherever you happen to be.

Pencils and pens

The first step is to choose something to make marks with. Shown here is a selection of sketching tools along with the different marks they make on the page.

If you're inspired to do a quick sketch but don't have your usual sketching tools with you, don't worry! Just have a look around and see what's nearby – perhaps something from your bag or desk such as a biro or pencil, or even a marker pen.

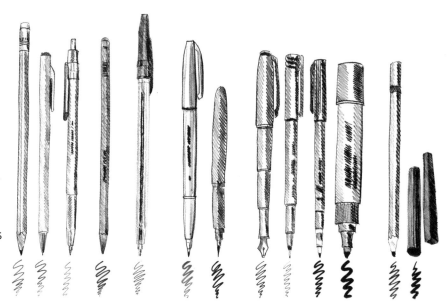

Different sketching tools and the marks they make Left to right: graphite pencil; revolving/mechanical pencil; clutch pencil; woodless graphite pencil; biro; felt-tip pen (grey); brush pen; calligraphy fountain pen; fineliner or drawing pen; permanent marker pen (medium); permanent marker pen (thick); charcoal pencil; charcoal sticks.

Notice the differences and similarities between the marks, which vary from thick to thin (marker pen vs biro) and from dark to light (charcoal vs pencil). In the following pages you'll discover how to use these tools to create different effects, for example, a pencil for finer detail but a thick permanent marker pen for large, bold and expressive marks.

Graphite pencils are available in different grades, ranging from very hard and fine (9H) to very black and soft (9B). 'H' stands for 'Hard' and 'B' for 'Black'. Throughout this book, for simplicity, we'll use a mid-range pencil grade (HB: Hard and Black) because it's commonly available, versatile and perfect for sketching.

There are advantages and disadvantages with any sketching tool. For example, fineliner and permanent marker pens make crisp, mono-tonal but permanent marks, so you cannot correct mistakes; whereas pencils and graphite pencils make multi-tonal marks that can be easily erased. The best thing to do is experiment to find your favourites.

Paper

Paper is available in all shapes and sizes, from flat sheets, sketch pads and bound sketchbooks to large rolls. Smaller sketchbooks are ideal for sketching when you're out and about, particularly spiral-bound ones that allow you to fold the book back on itself, thus avoiding the pages trying to close as you sketch. Loose, flat sheets and larger sketchbooks are better suited to sketching large-scale work indoors.

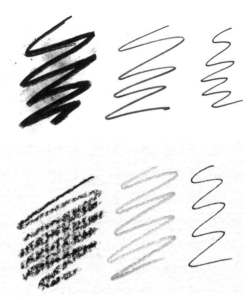

Smooth (top) and rough (bottom) surface texture with three sketching tools: charcoal, HB pencil and ink pen.

Paper is available in different thicknesses (or weights). You'll usually find this information on the sketchbook cover or the packaging of loose paper, written as grams per square metre (gsm) or pounds (lb) per ream (500 sheets). Papers range from thin 80gsm (50lb) to better quality, thicker 200gsm (120lb). Boards tend to be heavier (thickness measured in microns, 1,000 of a millimetre) and the higher the value, the thicker the board. Thicker paper tends to be more expensive and is not necessary for most sketching; cartridge paper (120–130gsm/75–80lb) is generally fine for the purpose.

Paper may have a smooth surface (such as Bristol board) or a rough one (for example, the rough grade of watercolour paper). Smooth paper is great for ink and graphite but it's harder to create different tones than on a rougher surface; charcoal can easily become smudged as it doesn't really adhere to the paper surface (see how it's smudged in the figure above). Rough-textured paper has more surface 'grip' (or 'tooth'), is better for charcoal, and can result in interesting textures from both pencil and ink.

Of course, you can sketch on anything. Years ago and with time to kill, I sketched my surroundings on the only available paper – the inside of a thin paper bag. It was not ideal as it had images of hardware goods printed all over the other side!

Scrap paper is very useful for trying out ideas. If you're feeling adventurous, why not try sketching on coloured, patterned or graph paper?

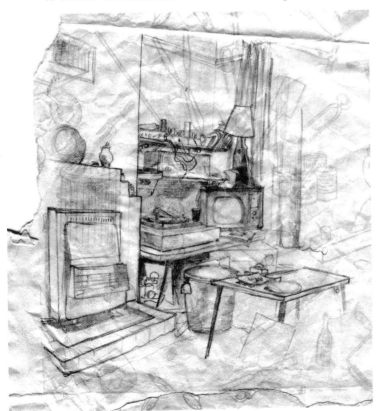

Sketch on a paper bag (left).

11

Erasers and sharpeners

When sketching you probably won't need (or have time) to use an eraser, but it's good to have one handy. A plastic or vinyl eraser may be a block, pencil, or end-of-pencil eraser; in each form it will remove most unwanted marks cleanly and completely. These erasers can be cut into smaller pieces for precision work, but they may leave crumbs on the page and, worse, over-enthusiastic erasing may wear holes in your paper.

Putty or kneaded erasers can be shaped and moulded to gently lift off graphite and charcoal from the paper surface without smears or paper damage, but they may not erase as efficiently as a plastic or vinyl type.

A pencil sharpener, craft knife or small sandpaper block (sandpaper sheets stapled to a backing board) will make a portable sharpener for your graphite/charcoal pencils. The first is safe and easy to use, though a blunt sharpener blade may break pencil leads. A craft knife will create long and fine or wedge-shaped pencil points, while a sandpaper block will keep points very fine.

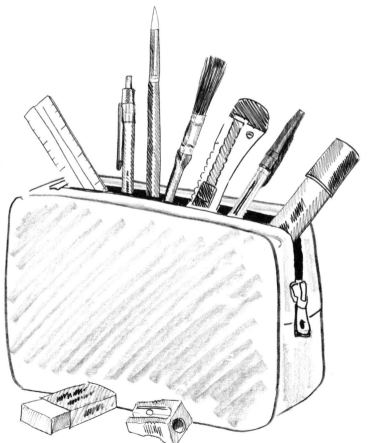

These are all the basics you need with which to start sketching. You may want to add a zip-up bag to carry them.

Other accessories

As your sketching develops, other items you may
find desirable include: a space-saving elastic band
to secure pages open or clips to affix paper to a
board to stop your paper blowing away; and a clear
plastic ruler should you need to measure anything
or if, like me, you struggle to draw straight lines
(for example, lines of perspective).

A small, clean paintbrush is useful to brush away any eraser crumbs (rather than use
your hand and risk smudging, or moisten the paper by blowing them away).

If you use charcoal or graphite, a modelling brush with a soft silicone tip creates
beautiful soft, smudged effects. It's more accurate than a tissue and much better
than a greasy fingertip. Similar 'blenders', 'smudgers' and 'burnishers' are available
and it's something you may wish to explore when you next visit an art store or
shop online.

Other practical items include wet wipes (to keep hands clean), a small screw-top
plastic pot for pencil sharpenings, and a travel-size hairspray for fixing charcoal and
graphite sketches so they don't smudge. If you intend to sketch in one place for a
while, it's worth investing in a small, comfortable, folding camping stool or seat mat.

Basic marks: lines

The best way to start is to jump straight in and start making marks like these on the page – even random marks and doodles. Have a go with a pencil or pen. As you do so, you'll realize you make these lines and shapes already when you're handwriting.

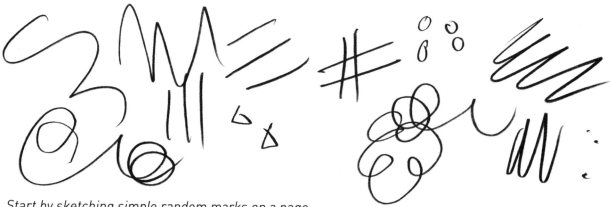

Start by sketching simple random marks on a page.

Most sketches are made from simple marks just like this but arranged in different configurations. Successful sketching is simply a matter of consistently making marks of the desired length, width, style and position on the page.

Once you practise the basics, you'll soon be able to make consistent marks as well as master different sketching tools. If you're a beginner, the following exercises are easy and fun; if you're a little more experienced, no practice is wasted! Relax and enjoy these exercises – there's no need to rush.

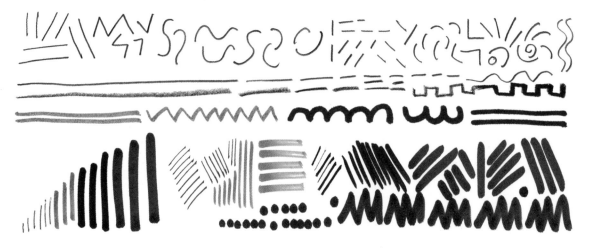

Practise these different lines.

Notice the effect of using different tools when you sketch these lines and shapes. The smaller marks here were created with pencil, biro and ink pen, the larger marks from charcoal, felt and marker pen, on smooth 200gsm (120lb) paper. Caution: more ink flows from thicker markers and can soak through on to any pages below.

Pencil points

You can also create thin and thick lines using different parts of the pencil point: (a) a thin line from an upright pencil and sharp point; (b) a thicker line from an angled pencil with a blunter point, and (c) a wider mark where the pencil lead is held flat against the paper. Try this for yourself, sketching these different line widths by altering the angle of the pencil on the page.

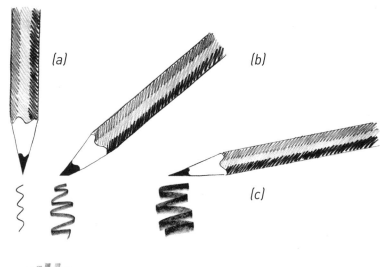

Sketch these thick and thin marks by altering the angle of the pencil.

Basic marks: light and dark

You can use lines to create areas of light and dark tone, or value, in your sketches to give the impression of depth and realism. First, try the techniques of rough shading, cross-hatching and dots shown here, then have a go at creating three shades of light and dark using different tools and techniques (see overleaf). You'll see that many examples in this book use just three shades: light, medium and dark (plus white, which is left unshaded).

Left to right: rough shading, cross-hatching and dots.

Practise sketching different marks and lines to create shades of light and dark.

1 Charcoal 2 HB pencil 3 Woodless graphite pencil 4 Biro 5 Biro 6 Fineliner 7 Fountain pen 8 Grey felt-tip pen 9 Medium permanent marker pen 10 Thick permanent marker pen.

Rough shading is best for graphite and charcoal, where different shades are created by altering the pressure on the page or using different hard/soft (light/dark) grades. Cross-hatching is more time-consuming, as various shades are created by successive layers of different directional strokes and varying intensity. This method is ideal for fineliner, biro, and fountain pens. Shading with dots is effective, but it's a lengthy process as light and dark shades are achieved by varying the size and intensity of dots. Of course, you can experiment and mix and match tools and techniques – for example, make dots with a pencil or cross-hatch with a thick marker pen.

The ability to sketch different tones consistently is a good skill to acquire and the exercise below will help you do just that. It uses three tones (light, medium and dark). I used sketchy strokes in HB, but you can practise this equally well with other tools.

Practise creating three tones consistently (light, medium, dark).

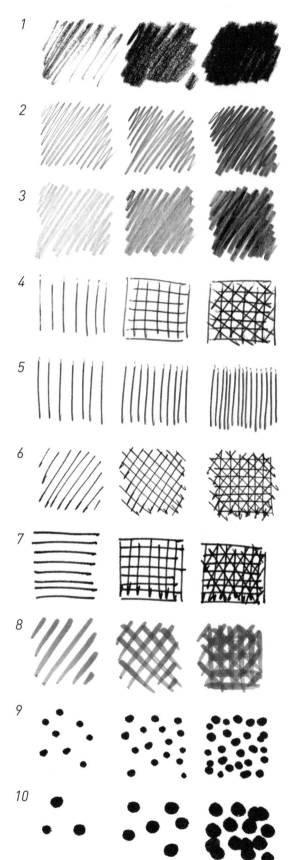

Basic marks: shapes

The ability to identify shapes will definitely help you when you need to simplify the subject or scene before you as you sketch. Below are some common basic shapes to practise: a *square*, *rectangle*, *triangle* and *circle*. Look for these shapes around you, and don't worry if your shapes aren't perfect at first – they will improve!

When grouped together, basic shapes can form a **composite shape** (or **outline** or **contour**). Outline, or contour, sketching is a speedy way to capture a scene and reduce detail; you don't need an in-depth understanding of your subject, for example, anatomy or architecture. The key things are to identify the lines and angles and where they intersect, and to gauge the correct proportions. Shapes between objects are known as **negative**, **enclosed**, or **trapped** shapes. Try sketching these various shapes, and then invent some of your own.

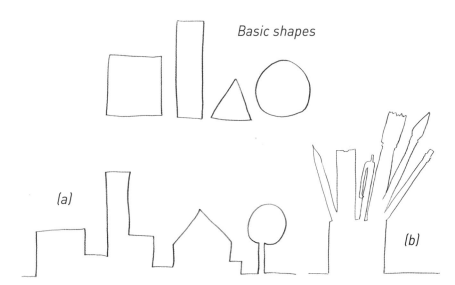

Basic shapes

A group of shapes forms a composite shape, in this case an outline (a) skyline and (b) desk tidy.

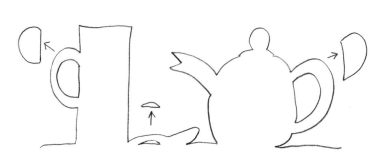

The negative shapes created by the mug, teaspoon and teapot are indicated by the arrows.

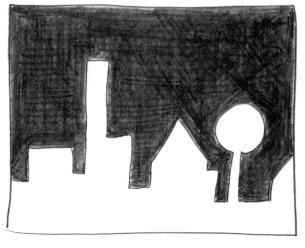

The shaded area is the negative space in this outline sketch.

Sketching the negative areas between or around objects can help to remove any preconceived ideas you may have about the shapes of objects, and you'll be more likely to sketch what's really there, rather than what you think is there.

Volume

So far, we've looked at shapes and objects in two dimensions on your page (width and height). Now we'll add a third dimension (depth) to give the impression of solid objects. Using the same basic shapes as before, add lines to create the three-dimensional objects illustrated below: a cube, rectangular box, pyramid and cylinder. (Note that the additional lines on the cube, box and cylinder are parallel.) The next step is to add shades (tones or values) to create greater realism. We'll be looking at how to show light falling on objects in the next chapter (see page 31).

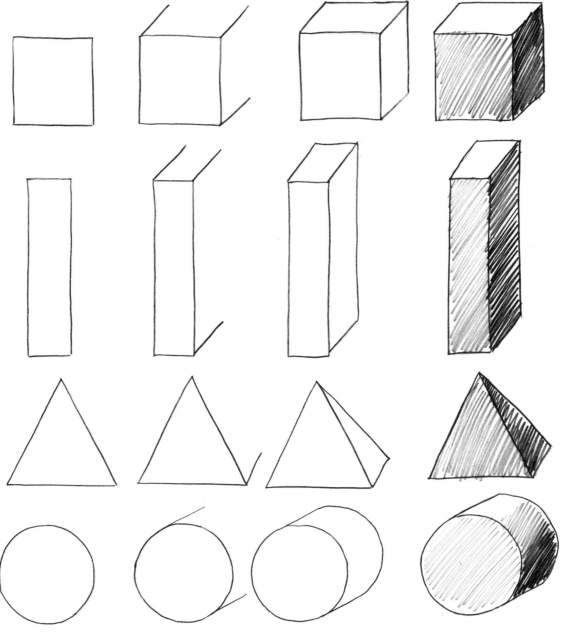

Add lines to shapes to create volume (the appearance of three-dimensional objects), then add shades (tones or values).

10-minute sketch: mugs

This exercise is about sketching the same subject in different ways. I've chosen a mug, an everyday object which uses the lines and shapes we've already looked at. Pick a few of these to sketch in a 10-minute slot, perhaps in your coffee break. Don't worry about being accurate – it's a chance for you to explore different techniques and styles, and to let your imagination run riot.

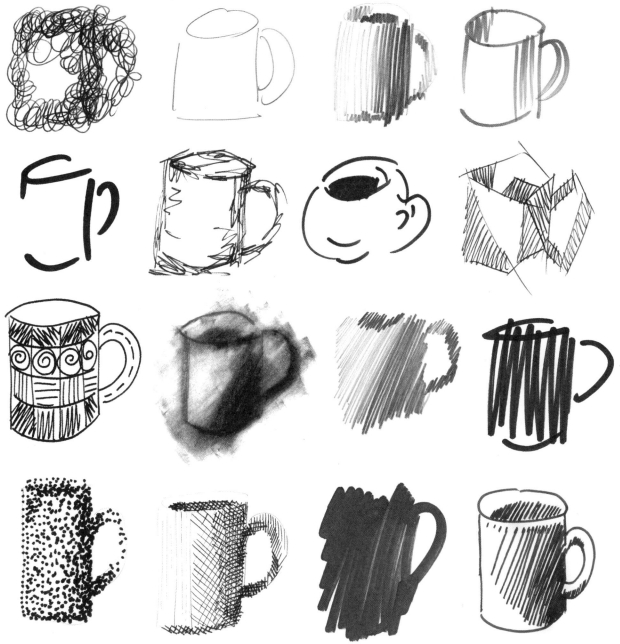

Use marks and lines to draw mugs in different styles *Left to right, top to bottom: biro (scribble); HB pencil (outline); woodless graphite (tonal); felt-tip pen (monotone); thick permanent marker (impressionist); fineliner pen (shaky); permanent marker (simplistic); biro (cubist); fineliner pen (decorative); charcoal smudged with modelling brush (blurry); HB pencil (diagonal tonal); medium permanent marker (zigzag); felt-tip pen (pointillist); fountain pen (cross-hatching); thick permanent marker (bold); fountain pen (diagonal lines).*

Practical considerations

While art is associated with inspiration and creativity, there are also some mundane practical matters that will help or hinder your progress.

Sitting or standing

Whether you sit or stand to sketch depends on your personal preferences, physical ability and location at the time; you may be sitting on public transport or in a café, standing in the street, or comfortably settled for an afternoon of sketching outdoors at an easel. You may find it easier to do smaller, more detailed sketches sitting down where you have better control over your sketching tool, and to make larger, very expressive, free strokes standing up. Experiment to discover what works best for you.

Size and time

The size of your sketch is usually related to the amount of time you have available. Generally, larger or more detailed sketches take longer than smaller or looser, sketchier works, so don't attempt to complete a detailed masterpiece in 10 minutes! Conversely, you may want to reconsider your style or technique if it takes a very long time to complete a rough sketch.

If you do run out of time, take a photograph to record any details so that you can complete your sketch later. Nowadays, most people have mobile phones with cameras that take good-quality pictures ideal for reference shots. Otherwise, a small camera is equally useful.

Fitting the picture to the page

Avoid starting with a small detail like an eye and building your picture around it because you can easily finish with a badly proportioned sketch or one that won't fit on the page. Planning your composition beforehand to ensure it fits on to the page avoids you finding you have too much or too little space left.

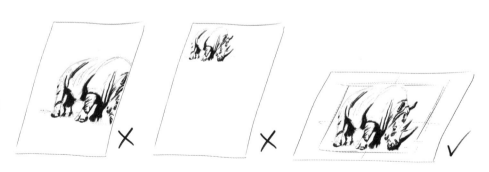

From left to right: Ensure you have sufficient space for your sketch; avoid squeezing into a corner; use faint guidelines to position your sketch centrally.

Just for fun: lines and shapes

Finally, here are some more shapes and doodles for you to sketch in your preferred style and medium. Designed to be sketched in a few minutes, they incorporate many of the elements we have looked at so far (different media, lines, tones, composites, negative space and volume).

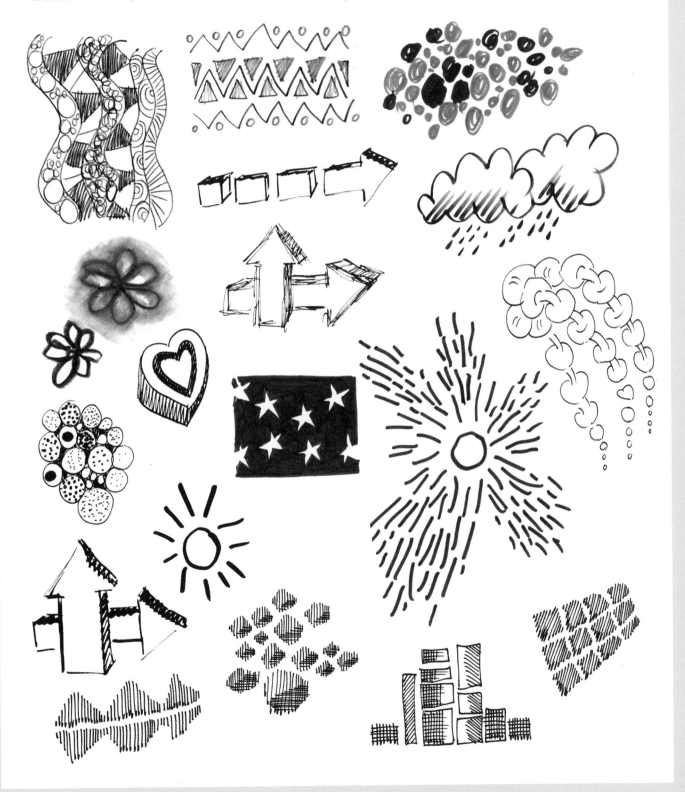

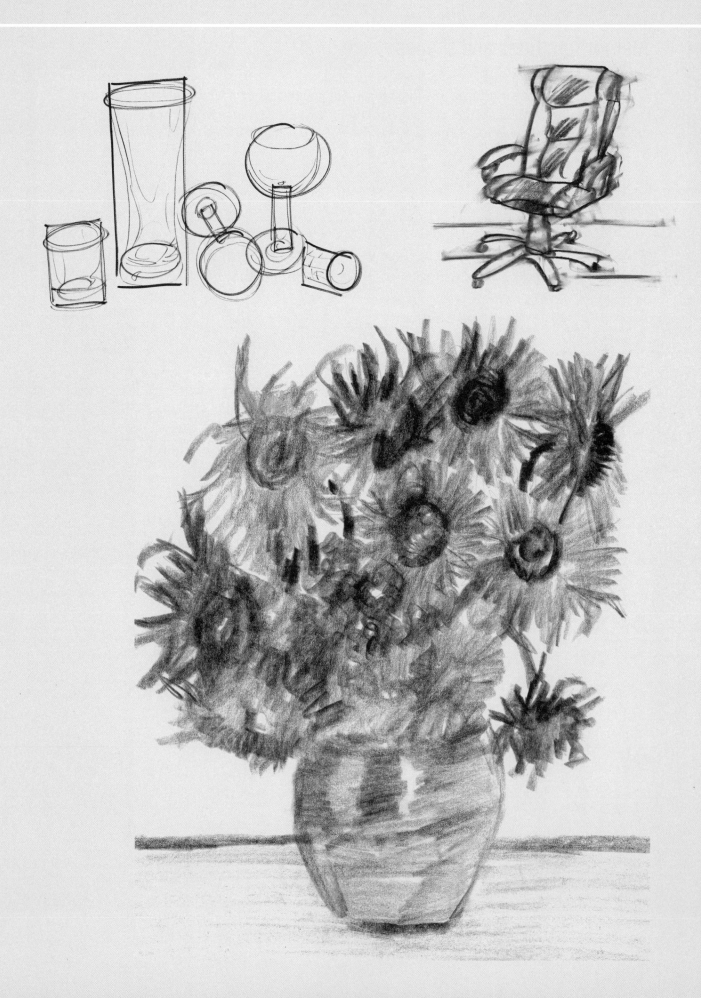

Chapter 2
FIRST SKETCHES

This chapter is about making your first sketches and improving your techniques, working from everyday subjects you can find around you in various indoor environments. If you're unsure where to begin, remember that sketches are simply composed of the various lines and shapes you've already practised, and you'll be able to identify these as you go along. We'll begin with simpler subjects that are easily mastered before attempting more challenging themes. They will all be inanimate subjects, so you'll have more time to sketch them!

The subjects include familiar items that you might find almost anywhere, such as straightforward boxes, everyday tableware, fruit and flowers, but also subjects you see all the time but may not have considered before, such as furniture and room interiors. Whether you want to spend ten minutes on a quick sketch or longer on a more detailed work, the examples encourage you to explore different styles of sketching, from minimalist impressions to more detailed cross-hatched and tonal works.

We'll consider various techniques such as how you can build your sketches from various shapes, then look at creating cast shadows and how to employ these to add even greater realism to your pictures. There are some helpful hints about attaining correct proportions in your work and you can also have fun getting to grips with perspective in the easy step-by-step exercises.

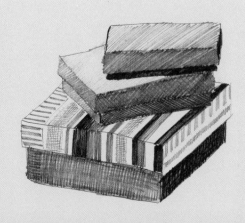

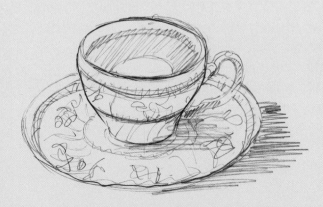

Still life

A still life is a sketch, drawing or painting depicting an arrangement of inanimate objects. Popular subjects include natural objects (fruit, food, flowers, plants, shells) as well as man-made items (books, vases, jewellery, kitchenware). A still life can be a single object or a collection of items usually arranged for a particular effect, whether that's to capture a moment in time, depict a religious or symbolic meaning, evoke emotions or challenge perceptions.

An example of a famous still life is **Vase with Fifteen Sunflowers** *by Vincent Van Gogh. To re-create the sketch I used woodless graphite, altering the pressure to achieve the light, medium and dark-toned radial strokes of the flower petals and blocks of tone on the vase.*

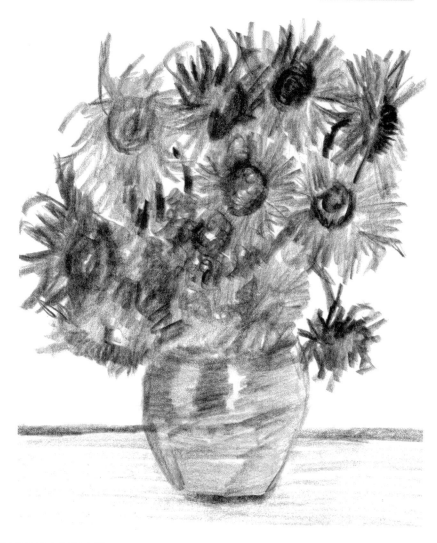

Still-life composition

You can choose almost any theme for a still-life composition (for example, music, travel, summer), include different materials (vegetation, glass, ceramics, fabric), and base arrangements on different attributes. These might be *object shapes* (square, cylindrical, egg-shaped, flat); *textures* (smooth/rough/matt/shiny); *size* (large/small); *tones* (light to dark, graduated); *alignment* (horizontal, vertical, angled); or *abstract concept* (unity, harmony, strength, solitude, contrast). As you can see, still lifes can be arranged in many ways and it's a matter of experimenting until you find a balance of objects that looks pleasing to the eye.

Still lifes in simple shapes

Before you begin a sketch, it's a good idea to warm up with a few scribbles on scrap paper.

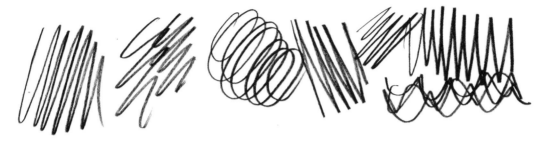

THREE GIFT BOXES

In this first still-life example, we start with some straightforward box shapes sketched in different styles. To add interest to the composition, they're arranged at different angles. If you don't have any boxes to hand, books are a good substitute.

If you're not sure where to start, identify any shapes in your subject and roughly sketch them on scrap paper to help you gauge their relative sizes and positions. Then have fun sketching them without looking at your paper at all (known as blind sketching). This will encourage you to really look at your subject, rather than at your drawing. It doesn't matter if your first attempts look terrible – your sketching skill will improve!

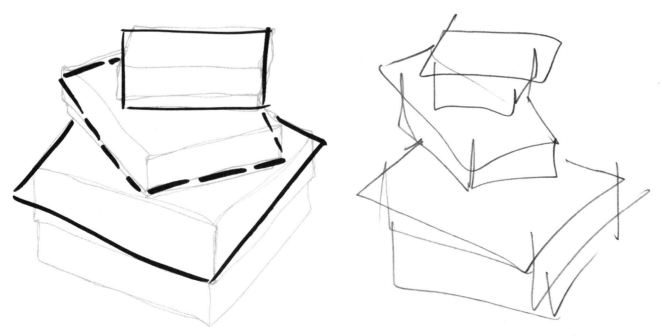

First, look for any shapes in your subject (outlined here in grey felt pen). It's good practice (and fun) to sketch without looking at the page (blind sketching), illustrated here in fineliner pen.

Next, try these two sketches. You can use a fineliner pen as I have done, or another medium of your choice. The contour sketch requires a keen eye and concentration to produce a contour of all the outside edges and angles of the boxes. While you may be able to sketch a good outline, notice how difficult it is to identify the subject from the outline alone.

Outline or contour sketch in fineliner; it's not always easy to recognize the subject from its outline.

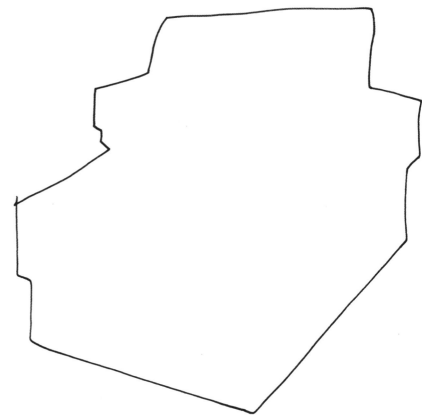

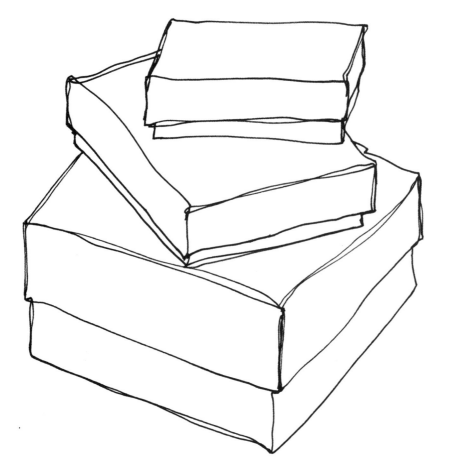

The simple box sketch now shows the details inside the contours. If you're feeling brave, test your skills of observation again and sketch the boxes as one continuous line without lifting your pen off the page, retracing your lines in places if necessary. Again, consider the object shapes, line angles, and where the lines intersect. The objects here are immediately identifiable and make a simple but pleasing composition.

In this simple box sketch, the boxes are drawn as a continuous line in fineliner.

If you have a little more time, use an HB pencil and three tones (light, medium and dark) to add decorative details to the boxes. Lightly sketch an outline of the boxes, then use rough shading and cross-hatching to decorate them. The use of cross-hatching also allows you to create an additional shade between 'medium' and 'dark'. Notice how the additional patterns and tones create more interest.

Outline pencil sketch (right) with details added in three tones using shading and cross-hatching (below).

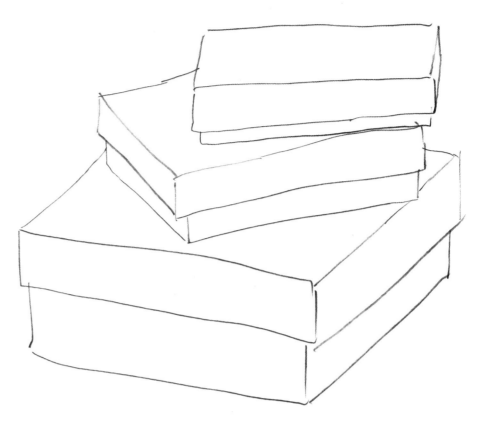

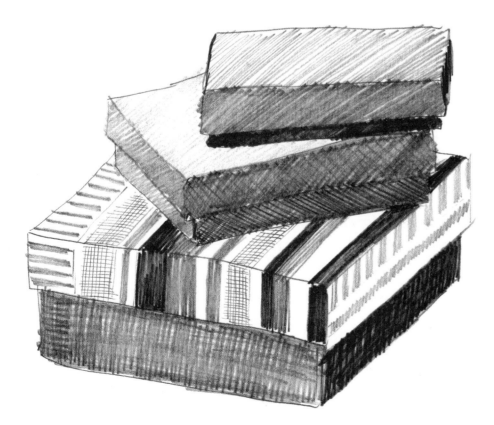

This simple box stack looks quite plain by comparison and needs some extra objects of different shapes or textures to make it a more interesting composition.

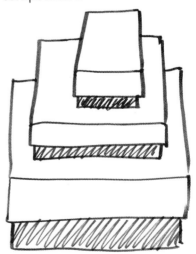

Box stack sketched in felt pen.

DRINKING GLASSES *(fineliner pen)*

This still-life selection of drinking glasses of different circular and elliptical shapes is arranged to please the eye. The shapes may appear complicated to draw at first compared to the regular shapes of boxes and rectangles, but practice makes perfect! The clear nature of glass means you can sketch these easily and effectively as imprecise outlines.

As before, begin by looking for the various shapes in the arrangement and either produce a practice sketch, or thumbnail, on scrap paper, or sketch faintly as an underdrawing on your page. Then produce your final sketch in your preferred medium. As you can see, the lines don't need to be exact – in fact, the hesitant and slightly scribbled style adds a touch of originality.

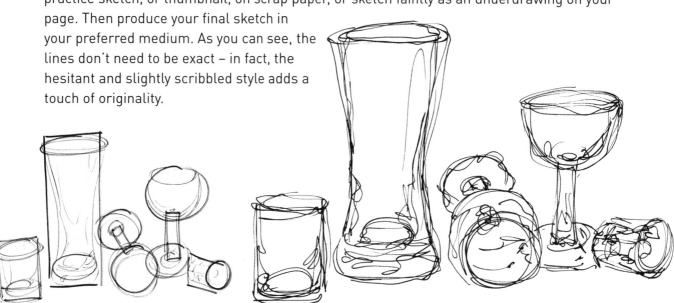

The shapes and relative sizes are identified first (left), then sketched with a fineliner pen (right).

Tips for drawing circles and ellipses

Here are a few ways to perfect rounded shapes. Note that circles and ellipses are symmetrical shapes and it often helps to draw a centre line as a guide.

You can draw a circle in a single stroke, as two halves or as four sections within a square grid. Ellipses look like squashed circles and can also be sketched in single or multiple strokes. Ellipse shapes are always rounded and do not have pointed corners.

A circle sketched in a single stroke (a), two halves (b), and four sections (c); an ellipse sketched in a single stroke (a) and as four sections within a rectangular grid (b) and (c).

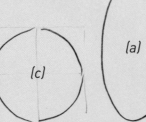
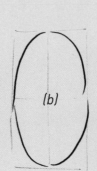
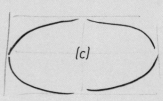

TEAPOT AND TEASPOON
(biro)

If you have a few minutes to yourself during a lunch break, perhaps eating out in a café or restaurant, have a go at sketching the objects in front of you on the table. You'll find a range of shapes and surfaces to tackle in even the most basic items.

Observe the objects, look for the main shapes (sketch these as a thumbnail if needed), and then sketch what you see. It's fine to have several attempts as you get used to capturing the items on paper. You could also try to sketch them as an outline but it's not always easy to see what they are.

This metal teapot and spoon were sketched in biro on cartridge paper. The aim was to capture the different shapes and shiny textures with simple lines, including the negative shape of the teapot handle.

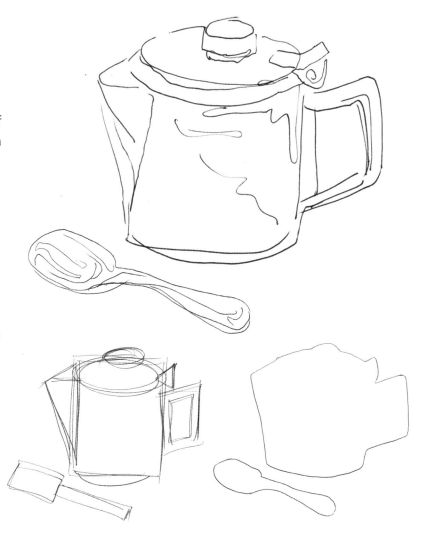

SILVER KEY (fountain pen)

Most of us carry around a key or two so, if you have a few spare moments in a busy schedule, a key will be something that's readily accessible for you to sketch. Try this in pointillist style, lightly sketching the outline then filling in with dots of varying density to create the light and dark areas. Pen and ink works well for this, but do feel free to try other media.

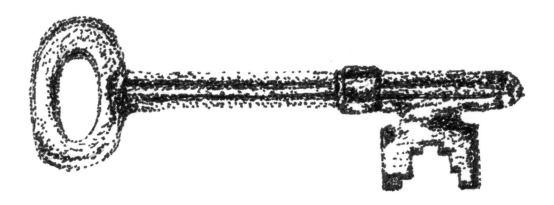

BOTTLE AND GLASS

Until now, the examples have shown objects which appear to be suspended in mid-air (that is, they are not shown to be resting on any surface), so the next examples contain more contextual information such as a few surface and background details.

Have a go at this still-life example of a wine glass, bottle and cotton napkin which contains more complex shapes (folded fabric) and shading. Starting with the same guideline drawing, you can choose from three different ways to sketch the same subject (or try all three!).

First draw very faint guidelines of the shapes as the basis of all three sketches (the lines have been darkened here to make them more visible).

Woodless graphite: Darken a few lines to show the overall shapes of the bottle, glass and napkin folds to give an open framework. Add the bottle top and label details, then shade just a few areas in very light tones.

Fountain pen: Use the same guidelines as before but this time depict the object shapes with clear, bold strokes. Add a few squiggly lines and patches of dark tone to create the impression of highlights and reflections, plus a splash of ink spots as a final flourish. Erase any unwanted guidelines.

Fragmented sketch in charcoal: Using the same initial guidelines, add outline diagonal stripes across the entire sketch and shade segments of each stripe in graduated tones.

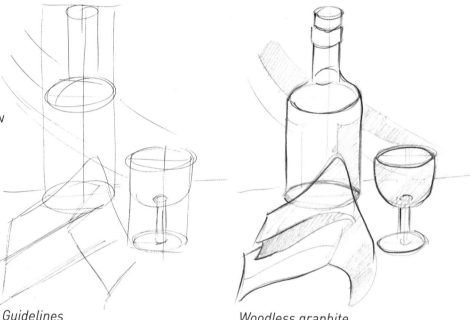

Guidelines

Woodless graphite

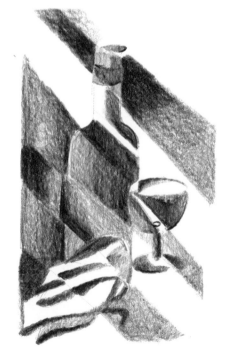

Fountain pen

Charcoal sketch

Shapes and shadows

You may have noticed that one of the gift box examples on page 27 introduced darker shading on the right-hand sides of the boxes, and this was to show areas of shadow. Of course, we need light to see, and the presence of shade and shadow (darker tones) not only indicates a light source (lighter tones and highlights) but also helps to create the illusion of depth and volume.

The darkest side of an object (and any shadow cast on the surface on which it stands) is always on the opposite side from the light.

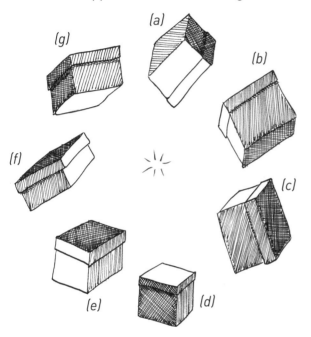

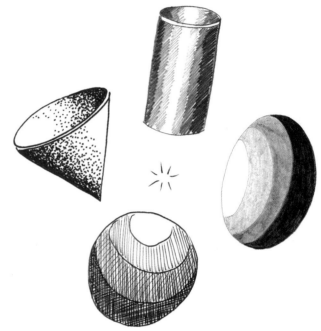

Boxes around a central light source illustrating the shaded sides on the opposite side of the light source. Can you spot the odd one out? (The answer is at the bottom of the page.)

Other shapes around a central light source showing light and shade patterns (clockwise from top: HB roughly shaded cylinder, woodless graphite shaded egg, biro cross-hatch sphere, fineliner pointillist cone).

When an object is placed on a surface you can easily work out where to draw any cast shadows, as shown by this lamp and mug on a table beside a wall. For the **shadow length**, follow a straight line from the light source, skimming the top of the object until it reaches the surface behind it (the wall). For the **shadow width**, follow a straight line along the surface from the point directly below the light source, past either side of the object until the shadow's length is reached (against the wall).

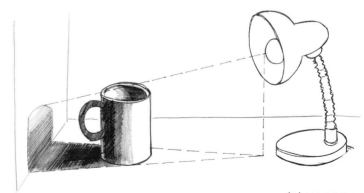

How to work out the shadow cast by an object, for example, a mug illuminated by a table lamp.

Answer: (e)

31

TWO CANS: QUICK SKETCHES

Now, quickly sketch these empty tin cans which demonstrate that very few lines are needed to describe the shapes of objects and the surfaces beneath them. For speed and effect, I chose permanent marker pen in a minimalist style and charcoal smudged with a modelling brush.

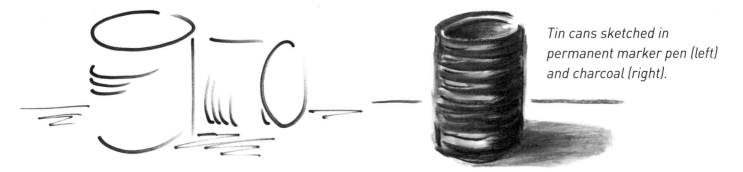

Tin cans sketched in permanent marker pen (left) and charcoal (right).

Different shadows

Shadows are affected by weather, sunlight, moonlight or artificial light. They are darker and sharper when the light is brighter (bright sunshine or moonlight) and hazy, fainter or altogether absent on duller or foggy days.

As a beginner, you may produce a sketch that is unevenly or incorrectly illuminated – for example, if sketching outdoors on a sunny day you may include a confusing spread of shadows as the sun moves across the sky and changes the scene. To avoid this, it's best to decide on a single source of light and sketch the light, shade and shadows accordingly. For the sake of simplicity, it is assumed throughout this book that there is a single light source, such as an electric light bulb or the sun.

This diagram is another example which shows how easy it is to sketch the shadows cast by objects of different shapes. Here, the point on the surface directly beneath the light source (the sun) is also the *vanishing point*, where your line of vision meets the horizon (see perspective, p.33).

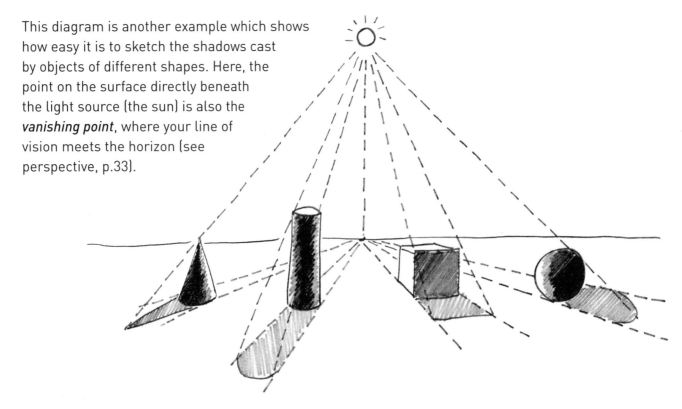

Perspective

To create the illusion of a three-dimensional picture on a two-dimensional page, you need to use perspective in your sketches. Understanding how to do this will help you to portray objects more accurately and to create realistic scenes.

There are two different types of perspective. *Aerial*, or *atmospheric*, perspective creates the illusion of depth by using darker tones in the foreground and progressively paler tones towards the distance. It is illustrated here with a sketch of a mountain range (see right).

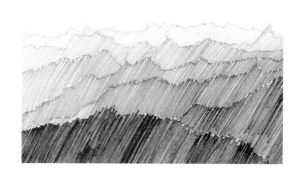

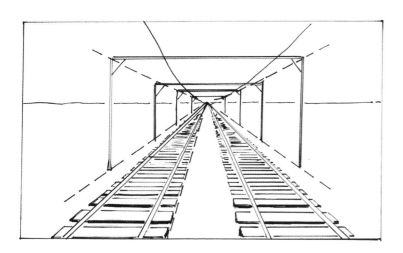

Linear perspective is a way of representing objects in relation to each other, the objects appearing to become smaller the further away they are from you. There are three types of linear perspective.

In *one-point perspective*, parallel lines appear to converge to a single vanishing point on the composition's horizon line. For example, parallel railway tracks appear to narrow as they recede into the distance (see left).

Two-point perspective has two vanishing points and is illustrated here with giant baby blocks, which appear to diminish as they disappear into the distance. The two vanishing points are at either side of the sketch on the horizon line. Note that there are vertical lines but no horizontal lines. In this instance the blocks are shaded as if the light source is from the right.

In *three-point perspective* the third
vanishing point is not on the horizon
but above or below it (usually off the
page). You'll notice this effect with
very tall buildings, such as cathedral
towers or skyscrapers, that appear to
bend inwards with increasing height.
In this close-up view of the corner of a
skyscraper, the three vanishing points
are the dots outside the picture frame
(above, right and left).

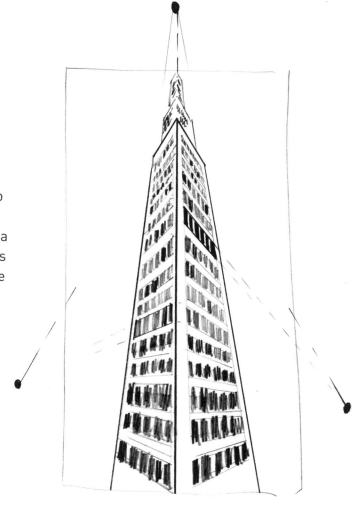

Perspective and composition

You can also enhance the illusion of perspective in your composition by the placement of overlapping
objects. These images illustrate how difficult it can be to judge the relative distance of objects when
they are wide apart (left), but when you overlap them (right) it's much easier to understand how they
relate to each other in the space.

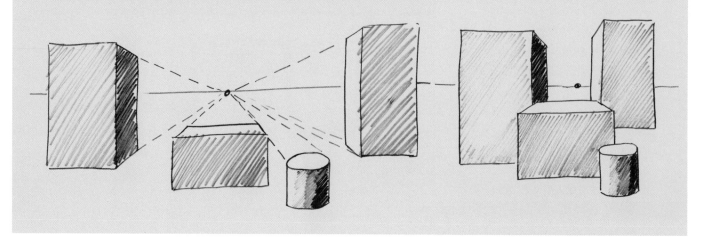

ONE-POINT PERSPECTIVE, STEP BY STEP

In this example you'll discover how to sketch a scene with a single vanishing point on the horizon. Use a ruler to draw the lines here if you don't have a steady hand.

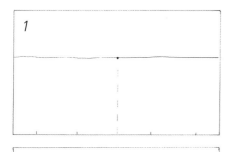

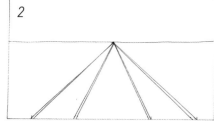

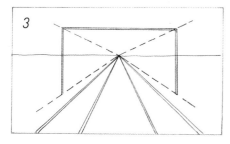

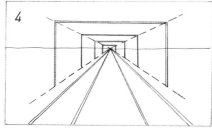

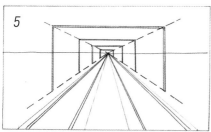

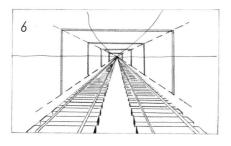

STEP 1

Lightly mark out a rectangular drawing area in landscape orientation and draw a horizon line just above the halfway mark. Add a dot in the centre of this line to represent the vanishing point (VP). Lightly sketch a dotted line vertically down from the vanishing point to the bottom edge of the rectangle. Add two pairs of equally spaced marks along the bottom edge each side of the centre line. These marks are the ends of the two sets of rails. Erase the dotted line once you have completed your measurements.

STEP 2

Draw double lines from the ends of the rails to the VP.

STEP 3

Draw double vertical lines on either side from just above the rail tracks to about halfway between the horizon and top edge of the rectangle, equidistant from the central vertical line. These lines are the poles for the overhead wires. Join the tops of the poles with two horizontal lines. Lightly draw broken perspective lines from the tops and bottoms of the poles to the VP.

STEP 4

Use the broken lines as a guide to add the remaining poles in perspective, remembering to space the poles closer together as they recede.

STEP 5

Add faint lines of perspective on either side of each pair of rail tracks (four lines in total) to mark the inner and outer edges of the railway sleepers. Ensure the inner edges of the sleepers are further away from the rails than the outer edges.

STEP 6

Draw horizontal lines for the sleepers between the perspective lines, nearest sleepers first, ensuring the sleepers become narrower and the edges taper towards the vanishing point. Create depth to the sleepers by adding very short vertical lines down from the ends, then thicken the inside end edges. Finally, add two overhead cables.

TWO-POINT PERSPECTIVE, STEP BY STEP

Next, sketch this group of objects with two vanishing points on the horizon. Here they are shown as blocks, but they could also be a group of buildings on a street corner.

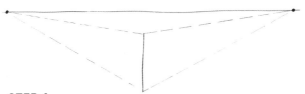

STEP 1

Draw a horizon line across the centre of the page with a dot at each end. These dots are the two VPs. Draw the first short vertical line below the horizon line. This is the nearest corner of the first cube. Lightly draw broken perspective lines from the top and bottom of the vertical to the VPs.

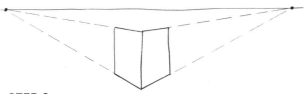

STEP 2

Draw the second and third vertical lines between the perspective lines (these are the other edges of the cube). Complete the top and bottom edges of the cube by drawing along the perspective lines between the verticals.

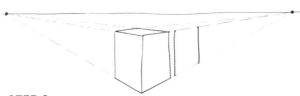

STEP 3

Lightly add two more guidelines from the tops of the second and third verticals to the other VPs (these will help you draw the rear sides of the cube). Draw solid lines to complete the top of the cube. Start an adjacent cube by first drawing two vertical lines between the broken perspective lines (this is the visible face of the cube).

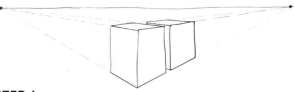

STEP 4

Complete any remaining visible parts using the same method as before. Don't forget to add a short vertical line to finish the partially hidden part of the cube at the back.

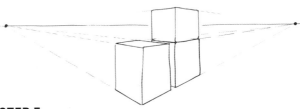

STEP 5

To add a cube on top, simply draw the nearest vertical edge of the cube, then construct faint perspective lines to complete the cube. Note: if your cube is not transparent, you'll need to erase part of the horizon line and some lines from the cube beneath.

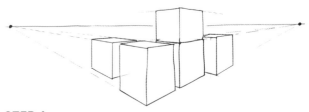

STEP 6

To add a recessed cube (left), draw the first vertical line so that it finishes above the bottom perspective line. To add a protruding cube (right), draw the first vertical line so that it extends below the bottom perspective line.

THREE-POINT PERSPECTIVE, STEP BY STEP

STEP 1

First outline a rectangular sketch area, portrait orientation. Add three dots around the rectangle, at the top, left and right (these are the three VPs). Draw a solid line in the middle of the rectangle from the bottom edge towards the top vanishing point, stopping short of the top edge of the rectangle. This is the corner of a tower block. From the top of this line draw three faint broken perspective lines to the three VPs.

STEP 2

Add the sides of the tower block by drawing two more solid lines towards the top VP, a bit shorter than the first. Complete the top of the tower by adding solid lines for the roof, then erase most of the broken perspective lines.

STEP 3

To add a row of windows on the right-hand side, choose a location and draw a very short line towards the top VP, parallel with the corner of the tower block. Then add two faint broken perspective lines to the right-hand VP.

STEP 4

Complete the solid lines then fill with small blocks of dark tone, ensuring the sides of the blocks align with the top VP.

STEP 5

Add another row on the left-hand side using the same method.

STEP 6

Fill the tower with rows, remembering that the lower floors will be taller and further apart. If you like, add more towers on the top!

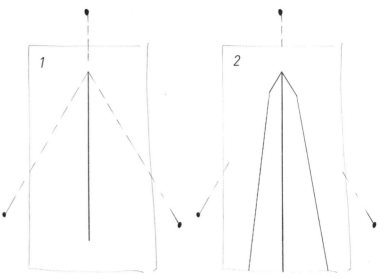

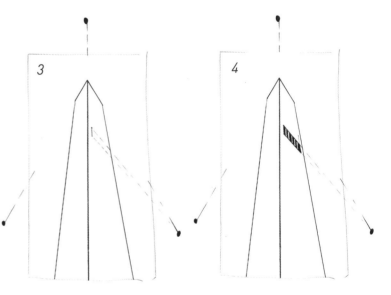

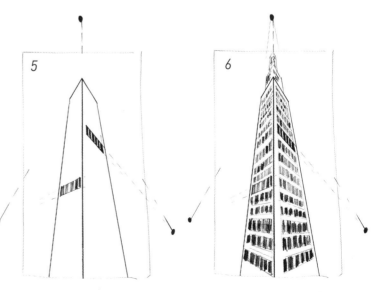

Proportions

Achieving the correct proportions is vital to producing realistic sketches since wrongly proportioned subjects simply don't look right, as seen with the apple below. Once you get the proportions right, surprisingly few details are then required for a subject to be recognizable – as illustrated here with a bottle, bowl, lightbulb and key.

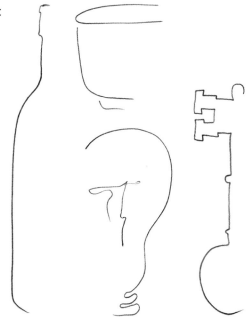

We're not all adept at gauging correct proportions freehand and you may think you'll never be able to draw as well as you'd like. But don't despair – techniques like measuring and using a grid will help you to draw accurately every time.

One way you can measure the scene or items in front of you is by using the *rule of thumb* and a pencil. Close one eye, hold the pencil in front of you at arm's length, and use your thumb to mark the height or width of the desired object on the pencil. Transfer this measurement to the paper. You can also use this method to work out proportions, for example, the height of an object might be twice its width. If you need to sketch *angles*, relate these to the hands of a clock.

If you're working from a printed image such as a photograph, you can use a *grid* to scale a drawing. Place, or draw, a grid over your printed image. Then draw a grid on your blank paper at the same size (or reduced or magnified, for example halved or doubled) and copy the image square by square.

If you prefer to draw freehand but have difficulty in reproducing reality, it may be that you're using your mind's eye – your idea of what an apple looks like, for example – rather than what is actually there. If this is the case, try sketching the subject upside down or sketch the negative spaces. Also, check that you're not looking at the subject from an awkward angle; your subject and your sketch should be in the same line of sight.

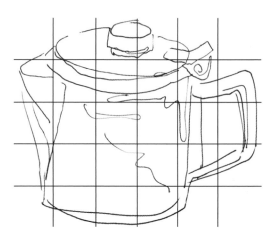

Still life: fruit

Fruit has been a popular still-life subject over the centuries and there are many famous paintings by great artists, for example *The Basket of Apples* (1895) by Paul Cézanne and *Basket of Fruit* (c.1599) by Caravaggio. Here we'll explore a few ways of sketching fruit with examples for you to try in different styles. Some can be drawn more quickly than others so you can choose which ones to tackle, depending on the time you have available. Of course, if you'd like to compose your own still-life arrangement of fruit almost anything goes, and you can include other items such as plates, containers, bottles and a tablecloth.

THREE APPLES AND TWO LEMONS *(HB pencil)*

Have a go at this first fruit still life, which can be completed quickly in mainly one tone. I used HB pencil on linen-texture card, but any paper or card will suffice.

STEP 1
First, roughly outline the fruits and plate.

STEP 2
Add rough, single-direction shading in three tones: light for the plate, and medium/dark for the fruit and shadows. Only a hint of a horizontal line is needed to suggest the edge of a table in the background.

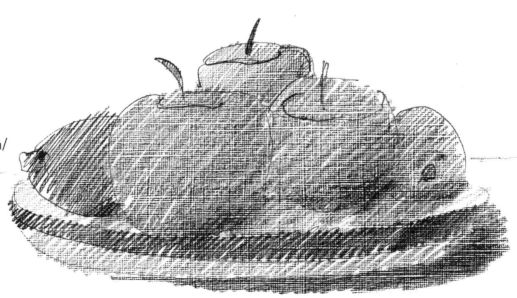

SCATTERED APPLES *(fountain pen)*

Now sketch the outlines of these scattered apples in the medium of your choice (I used a fountain pen). Don't worry too much about accuracy, just try to quickly capture the apple shapes (slightly indented base, thickish stalk centred in an ellipse). Then roughly shade half of each apple and add dense shadows on the surface. Two horizontal lines front and back give the illusion of the surface.

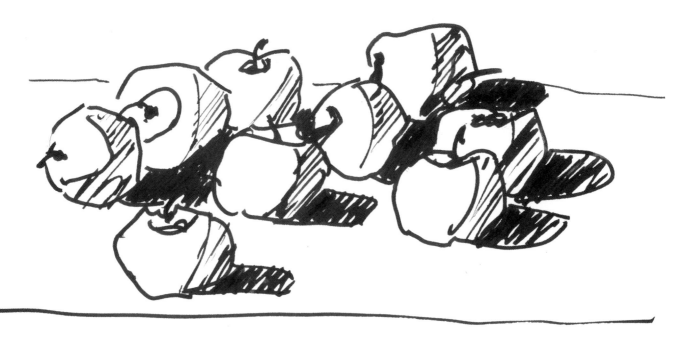

10-minute sketch: apple

If you'd like to attempt a little more detail but don't have much time, a single fruit such as this apple sketched in cross-hatched tones with an HB pencil is easily accomplished. You could also use a biro or fineliner pen. Begin by lightly outlining the apple shape then add strokes of varying density from top to bottom, following the apple contours (left).

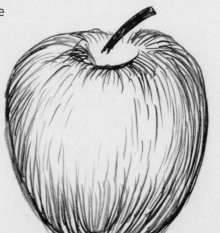

Following the contours again, this time add cross-hatch strokes from side to side across the apple (right). Draw more closely packed strokes in areas of dark shadow and leave highlighted areas blank.

SKETCHING CHALLENGE: STUDY OF CARAVAGGIO'S
BASKET OF FRUIT (HB pencil)

You may feel ready now to sketch something in more detail.
Try this sketch, illustrated step by step.

STEP 1

Lightly outline the rectangular sketch area, divide it into quarters to help you sketch the correct proportions, then roughly outline the main features.

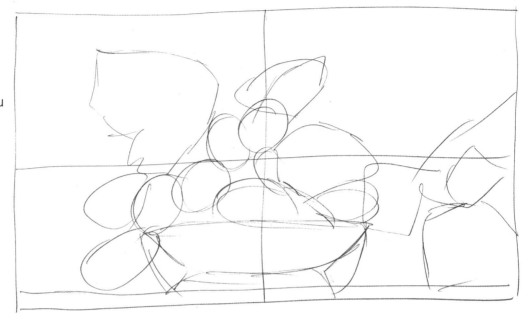

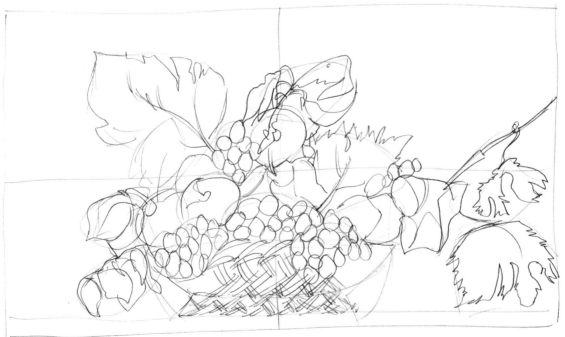

STEP 2

Next, refine the details across your picture. Rather than drawing just the outline shapes of the fruit and leaves, delineate all the main areas of dark shadow, bright highlights and mid-tones of the various elements so that you have made a plan of where your tonal work will be. Make any corrections if needed at this stage, then erase the guidelines and any other unwanted lines.

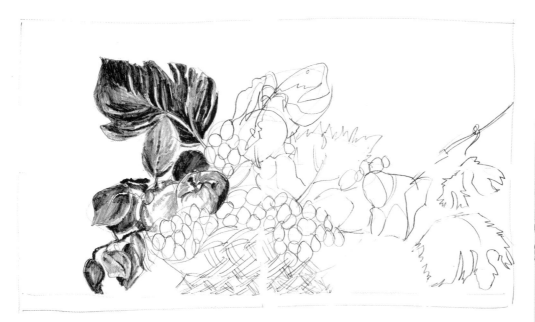

The inset shows that you don't have to be too precise filling in the tones to achieve a very satisfactory effect.

STEP 3

Begin to add the dark, medium and light tones, checking that you've achieved the correct balance of tones in one area before moving on to the next.

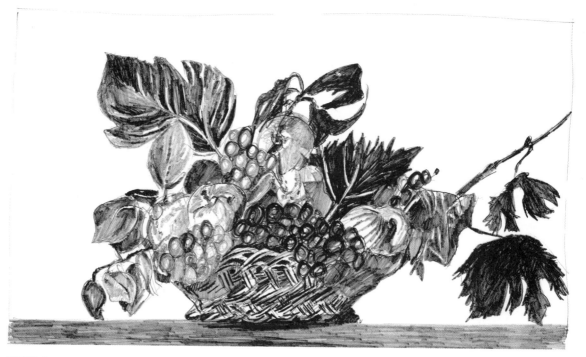

STEP 4

Continue to shade in the remaining areas of tone, remembering to leave highlighted areas blank. When filling in the detail, sketch in the direction of the contours, for example following the veins in any leaves. Notice the shadow underneath the basket which indicates that the basket is slightly overlapping the shelf.

Still life: flowers

Pictures of flowers are among some of the earliest still lifes in art. Notable flower paintings were produced by artists of the Dutch and Flemish Renaissance during the 16th century, and the term 'still life' is derived from the Dutch word *stilleven*. Many famous artists in later centuries, including Monet and Van Gogh, studied this subject and the examples on this page are inspired by well-known works of art. For speed of sketching, these examples show single lily flowers, although there is nothing to stop you composing your own arrangements or bouquets to sketch (see overleaf).

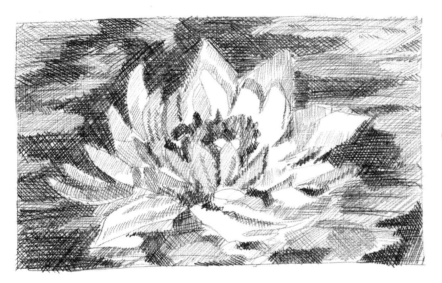

Studies of a lily inspired by: (top right) Leonardo da Vinci, HB pencil on linen-texture card; (right) Georgia O'Keefe, woodless graphite on smooth cartridge paper, then smudged with a modelling brush; and (above) Monet, cross-hatched HB pencil on linen-texture card.

Before you start, think about whether you would like to focus on a small section of a bloom or portray a whole flower, perhaps with full background details. Once you have chosen your subject and medium, outline the boundaries of your sketch, identify the main shapes in the subject and sketch these lightly on your page. If needed, use a grid square or rule of thumb to achieve the correct proportions. Next, identify the major areas of light, medium and dark tones and then fill in all the detail.

BOUQUET OF FLOWERS *(marker pen)*

Sometimes, it's good to think big and bold and sketch your subject expressively large on an expansive sheet of paper, like this bunch of flowers in thick marker pen.

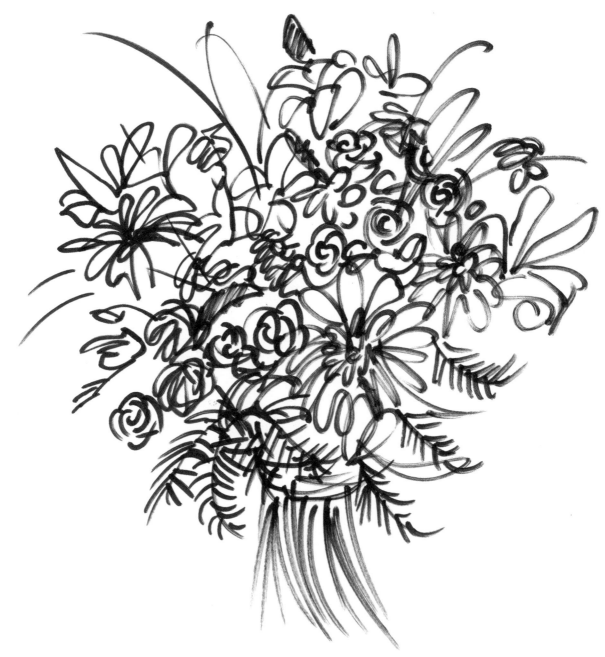

To sketch this wonderful bouquet, use a thick marker pen on a large sheet of paper such as A2 or even larger. Use very loose, bold strokes and try not to overthink this subject when you sketch. Instead, use your knowledge of creating different marks and focus more on the expressive, free feeling of creating the essence of flowers rather than replicating the exact detail. You'll see that the flowers and petals are simply clumps of different shapes and the leaves are either simple v-shaped 'herringbones' or strokes swished across the page. The stems are a few downward vertical strokes with two or three horizontal strokes at the top to suggest a ribbon.

Still life: chairs

Furniture is also a popular subject, depicted in many still-life studies. Although chairs are a common household and workplace item, there is plenty of scope to inspire you to sketch. They come in all sorts of shapes, sizes and materials, offering you plenty of choice. The angles and lines of perspective in these inanimate objects can make them tricky to sketch, so I've included an assortment of chairs for you to try. A couple of them can be sketched without worrying about too much accuracy, including a very easy wire-frame chair. I hope you enjoy the challenge!

Top to bottom: wire chair (biro); armchair (sketched blind in grey felt pen); office chair (smudged charcoal).

Take a little more care sketching the 'negative space' chair, which requires you to draw the spaces around the chair rather than the chair itself (a). Watch out for the legs (it's easy to miss one!) Fill in the background with (b) vertical then (c) horizontal strokes.

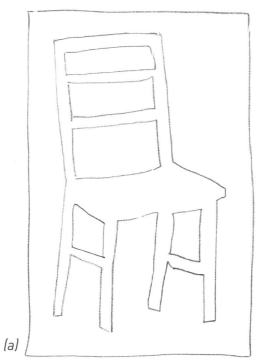

(a)

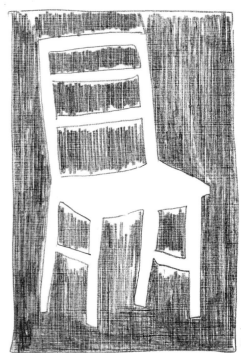

(b)

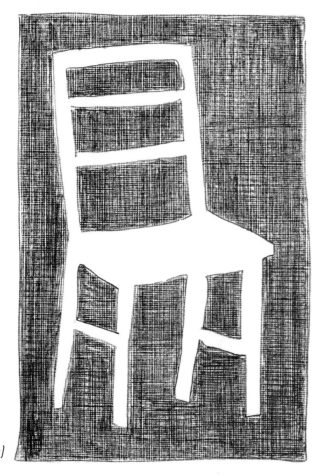

(c)

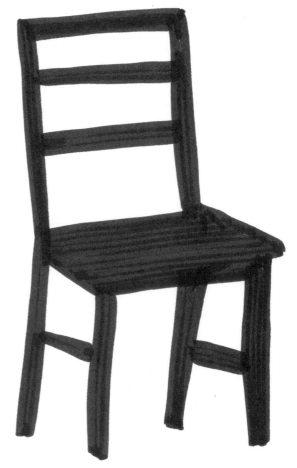

Negative space chair (HB pencil on textured card); silhouette chair (marker pen).

Interiors

So far, most of the subjects you've sketched have been individual objects or small collections of items. Now we're going to look at bringing together many of the elements we've covered in a view of a room. As before, the studies are in different styles and media and some are inspired by other artists but do feel free to sketch in your preferred way and to choose a subject of your own too.

ROOM STUDY
(fineliner pen)

This study of the corner of a room was inspired by the artist Edward Hopper (1882–1967). To sketch it in two-point perspective, use pen and ink to capture the main features of walls and doorways. Notice that the room has more than one view: from left to right, you first look through a doorway on the left into an adjoining room with a barely discernible table and window; then through another doorway on the right and into a corridor. Both points of perspective are shown in the thumbnails below.

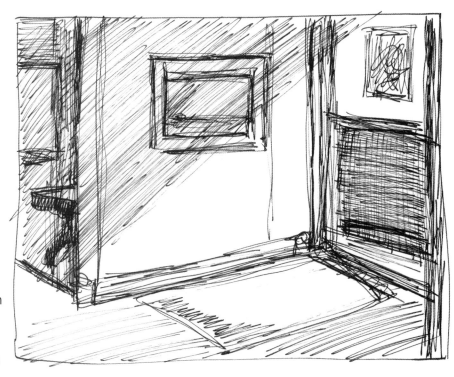

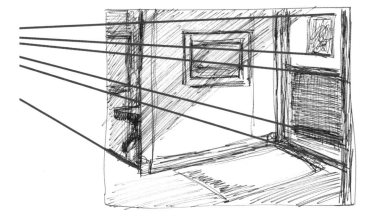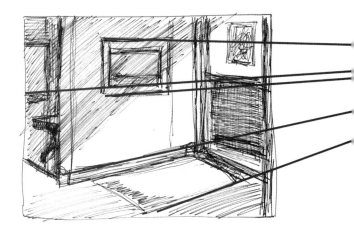

Use bold diagonal lines to emphasize the striking light and shade of the distinctive diagonal shadow on the wall, which indicates a light source in the upper right side of the sketch. Be aware of the different perspectives and two vanishing points: the lines of the hallway floor and dado rail appear to converge off to the left of the sketch; then the rug, skirting board and picture on the wall suggest lines which converge to a second vanishing point off to the right.

HOTEL ROOM *(biro)*

This hotel room is plain, with simple furnishings. Most of the shapes are rectangular, with one or two ellipses. See how the strong lines of perspective are revealed by the lines of the ceiling, the walls and bed and how the lines appear to converge to vanishing points off to the right and left. Once you have established the vanishing points and lines of perspective, it's relatively easy to create the angles of the bed. The angle of vision appears to create a bed with less length in the foreground because of the foreshortening effect.

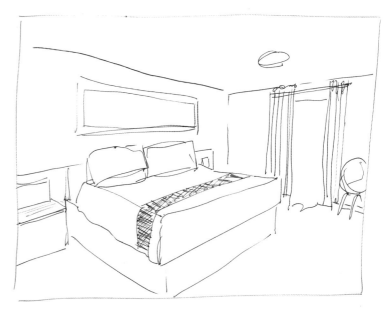

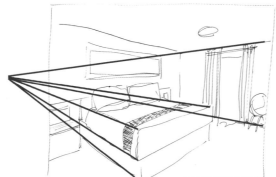
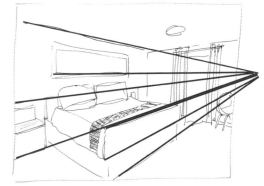

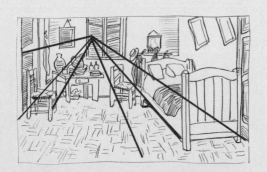

VAN GOGH STUDY *(HB pencil)*

To sketch this room inspired by the artist Vincent Van Gogh (1853–90), begin by outlining the bottom of the

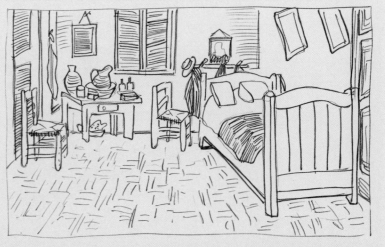

walls and converging lines of perspective to the single vanishing point. Next, add the main features and items of furniture such as the doors, window shutters, bed and chairs. Notice that not all the features follow the lines of perspective, and this gives the sketch a certain charm. Once you have sketched all the items in position, add details such as contour lines and the floor pattern.

Common errors

We all make mistakes, and in fact they're a great way to learn as they show us how to improve! It's not always easy to judge your own work with a critical eye, so you may need to seek comment from a friend who won't hesitate to be honest. Alternatively, it will help you to take a fresh look at your work if you half-close your eyes, hold it up in front of a mirror or trace the image and look at it in reverse.

Sometimes we can be too self-critical; I remember that when I was younger I would look at someone else's work and think I would never be able to draw as well as that. The fact is, we're all different, we all draw differently, and we all have to start somewhere. Best of all, we can learn! Sometimes, it just takes a willingness to be open to new ideas or to see things in a fresh light, as well as the enthusiasm to practise repeatedly and regularly.

Here are some common mistakes that can be easily overcome:

Unrealistic expectations
In your eagerness to practise, you might embark on a scene that's very complicated and then become disheartened. Rather than give up in despair, put that project to one side for now and focus on practising smaller, less ambitious subjects that will boost your confidence when completed.

Your sketches are too pale and you fear using very dark tones
If your sketches appear to lack substance, depth or realism, it's likely that the pencil you're using is too hard and your sketches need some dark tones or shadows. Although the harder grades of pencil can produce light and delicate tones, sketches really come to life when you introduce tonal contrast. Include softer grade pencils (for example, 2B to 8B) in your sketching, or vary the pressure of the pencil on the paper as you draw – this technique works particularly well with an HB pencil.

Using a very hard pencil will result in pictures that are too pale, such as this bottle sketched with an 8H grade pencil (left). Don't be afraid to use strong blacks to create a much darker-toned bottle (right), sketched here with an HB grade pencil.

Outlines
While outlines can be very useful when you're sketching quickly, jotting down ideas or doing preliminary work prior to creating the final work, their hard edges can spoil the effect in tonal sketches. In reality, very few features have hard outlines. You can create more realism with areas of tone rather than rigid lines for boundaries.

Here the use of tone defines the edges of petals and leaves (left) as opposed to drawing hard outlines (right).

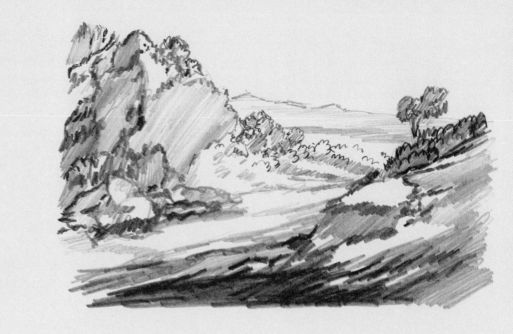

Chapter 3

SKETCHING THE OUTDOORS

We'll now turn our attention to sketching the outdoors, from small plots to wider vistas and from window views to objects in the landscape. We won't be encountering any new shapes and tones in our subjects – it's just that their size and complexity have increased. Some of the examples are presented in different ways to illustrate different techniques but also to inspire you to explore other possibilities and create your own ideas.

As before, there are quick ten-minute sketches for you to try as well as more detailed pieces of work shown step by step. You'll discover how to sketch views from your window and subjects from your garden, whether a window box or something larger. We'll look at various aspects of the outdoors including objects you might see in the landscape such as trees and interesting landmarks. There are also skylines and skyscapes for you to try, plus examples of how to portray different landscapes from mountains and rural scenes to lakes and waterside views. Don't forget that if you cannot venture outdoors to find your own subjects, you can always work from photographs.

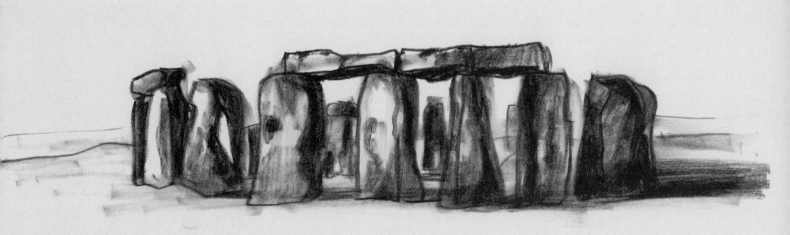

Choosing your subject and taking the plunge

When you're new to sketching, it's best to start small and work your way up to larger and more demanding works as your skills improve. Various factors will influence your choice of subject, such as location, the size of your paper, the weather and how much time is available. If you have only a few minutes to spare it makes sense to choose smaller scenes or individual subjects that can be completed quickly, unless you can take reference photographs to enable you to continue sketching later.

If you're daunted by a blank page or just not sure where to begin, break the ice by sketching random scribbles or practise familiar shapes and simple strokes to achieve a sketching frame of mind. Alternatively, just go ahead and make a sketch – if it's dreadful, anything you sketch after that will be better!

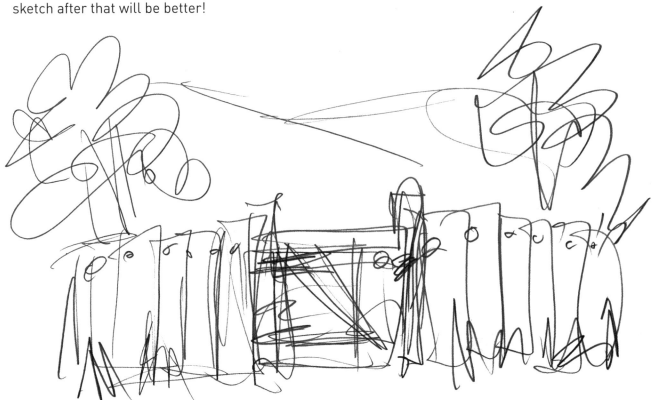

Through the window

An easy way to begin sketching the outdoors is to look through a window, which could be in your home, your place of work, a café and so forth. The advantage of this type of sketch is that you don't have to travel too far or brave inclement weather to capture your scene. You can also choose to sketch as little or as much of the view as you like, for example the view through a single pane.

ROSE CASTLE *(biro)*

To start with, here's a view through a section of a mullioned window at a castle – a landscape of lawn leading to fields, hedges and trees in the distance.

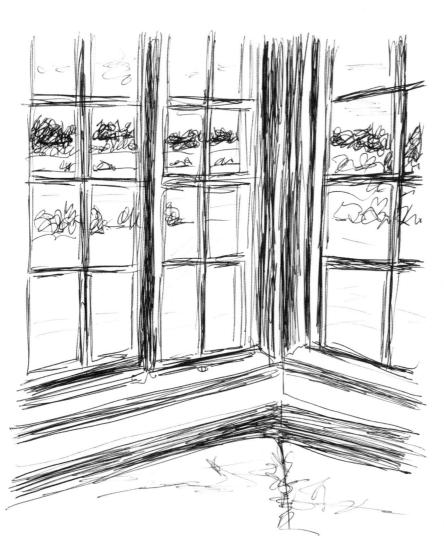

It's best not to spend much time planning or thinking about this sketch – just jump right in and sketch the window-pane shapes, mindful of the lines of perspective. As you can see from the uneven glazing bars, though, you don't need to be completely accurate.

Avoid solid blocks of tone and instead emphasize the window-frame details with simple vertical and horizontal strokes to suggest the texture of wood. Leave some strips of the window frame and sill blank to create a contrast between the light and dark shades. The lawn outside is almost empty apart from a few light-toned horizontal strokes, and the background foliage is a mix of fairly random leaf shapes. This sketch is intended to be completed quickly – if you want to add more detailed foliage and features to the hedges and trees, you can always sketch it differently next time.

EDINBURGH SUBURB *(HB pencil)*

Here we can see an Edinburgh suburb and a street that leads down to the beach and the tidal waters of the Firth of Forth with views across to the distant shore. The view is through the ground floor window of a house in an elevated position – for simplicity and speed of sketching, the window frame details were omitted. You'll notice that the area of water on the right of the sketch is left blank, illustrating how you can hint at a landscape feature such as open water or space without actually drawing any detail.

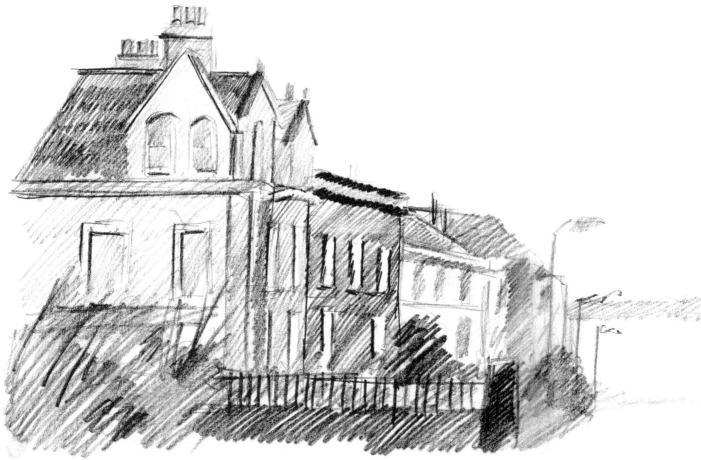

Sketch the shapes and lines of perspective first to achieve the correct proportions, then add the main vertical lines of each building. Next, add the different shapes and angles of the roofs and blocks of shaded tones for the walls, roofs and plants. To finish, create the railings from short parallel vertical strokes.

BALCONY AND WINDOW BOX VIEW *(HB pencil)*

This view from a window looks over a balcony and window box to a slightly more detailed landscape of city buildings. Because there are a lot of elements in this view, you will find it useful to plan your composition before adding any detail.

STEP 1

To create this scene, lightly outline the rectangular boundary of your sketch and divide it into quarters to make it easier to scale and position all the elements. Next, look for the basic shapes in the scene. You'll see they are mostly squares and rectangles with a couple of triangular shapes on the top of some buildings.

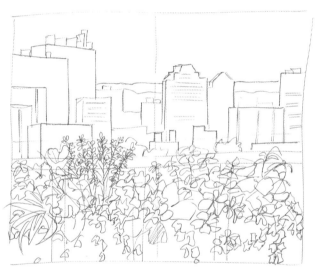

STEP 2

Refine any shapes then add essential details such as blocks of horizontal windows or vertical structures. You need only hint at a row of windows with a line or rectangle because the viewer's eye will fill in the rest. Create the effect of the densely packed different flowers and foliage in the window box by grouping together clumps of similar-shaped petals and leaves.

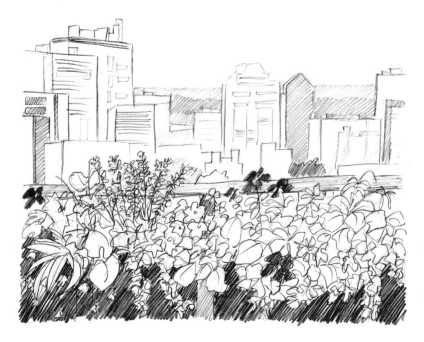

STEP 3

Finally, add a few areas of tone to the background cityscape in sketchy strokes. Use darker tones in the foreground and paler tones in the distance (aerial perspective) to represent either buildings or hills. Shade just a few flowers in dark tones and leave most of the petals and leaves blank. Apply dark tones to denote the shadows below the window box.

The garden

Whatever size your outside space, whether it's a window box, a few planters on a patio or a larger area with lawn and flowers, you'll always find something to inspire you. Here are some ideas for you to try.

10-minute sketch: small items

Smaller items associated with a garden may be sketched quickly and you can often find examples with interesting shapes.

Many people love to see wildlife at close quarters and a bird feeder is one way to attract birds to a windowsill or garden all year round. Make a few strokes to describe this minimalist-style bird feeder sketch in marker pen.

Garden tools come in many different shapes and sizes and a simple contour sketch is a great way to describe these items. Sketch each outline in biro as a continuous line.

It's easy to recognize this marker pen sketch as a pair of wellington boots. See if you can describe them in two or three lines as a contour sketch, not forgetting the trapped shape in the middle.

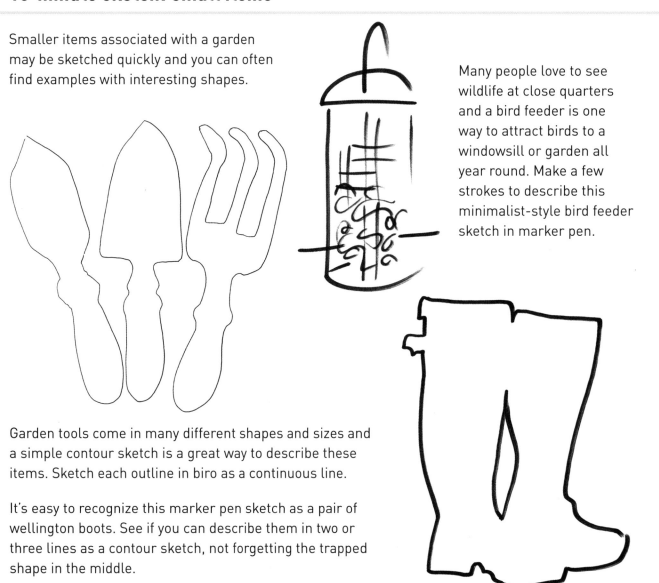

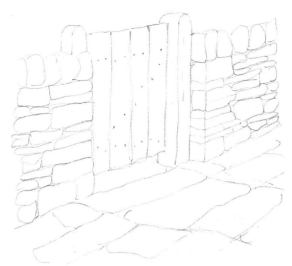

GARDEN GATE
(HB pencil on watercolour paper)

Sometimes it's interesting to sketch a small part of a scene, such as this garden gate set into a stone wall. The heavily textured watercolour paper adds interest to the sketch, but it can be difficult to achieve a full range of tones as the graphite doesn't adhere to the paper surface well and the paper can tear if you overwork the pencil. Nonetheless, the sketch has a certain charm and it's good to experiment.

STEP 1

Outline the rounded rectangular shapes of the stones and wooden gate.

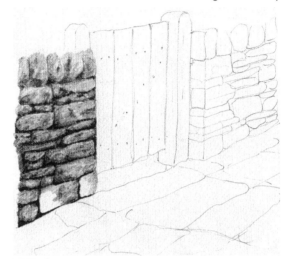

STEP 2

Fill the stones with mixed light and medium tones, adding darker tones at the bottom and left edges to denote shadows.

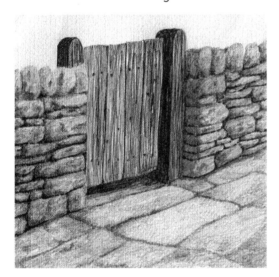

STEP 3

Complete the far section of wall in the same way. Use medium and dark vertical strokes to fill the gate panels and posts, adding fine wavy vertical lines for the wood grain. Fill the paving slabs with light and medium tones and show the edges in darker tones.

To sketch a corner stone, use a dark tone to outline the stone then fill with light and medium horizontal strokes of tone. On top of this, add a few darker-toned patches to emphasize the texture of the stone. Finally, add darker-toned shadows along the bottom edge and left-hand side.

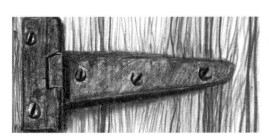

GATE HINGE *(charcoal)*

You can focus even further on a point of detail, such as a gate hinge. Outline the hinge in strong tones and fill with charcoal strokes, emphasizing the hinge detail and screws. Fill the wooden gate boards with various vertical strokes in different tones, leaving gaps between the strokes.

WALLED GARDEN *(woodless graphite)*

This impressionist-style garden has a light, summery quality, and is sketched in blobs of light, medium and dark tones. It was surprisingly time-consuming to do! Although it appears quite blurry, you can still distinguish the taller trees against a wall in the background and the flower borders and lawned area in the foreground. To create this sketch, first roughly outline the main areas of tone, then use a blunt point to make numerous small circular blobs to build up the tones.

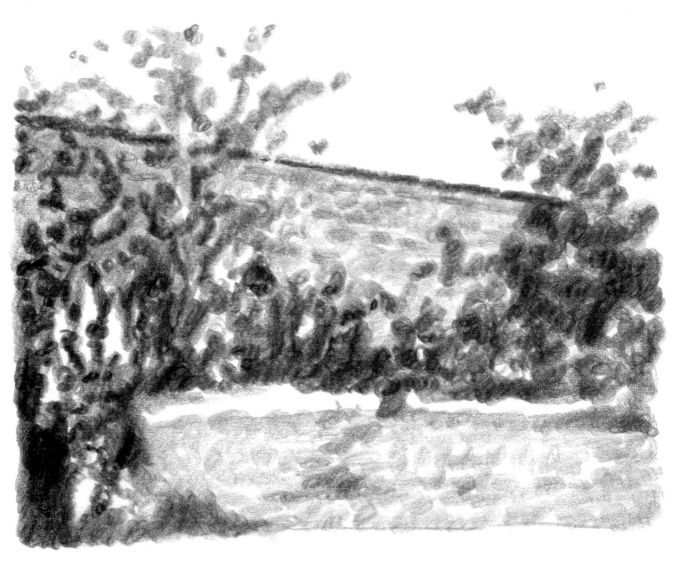

There's always time for a tiny quick doodle!

Vegetation

Most landscapes contain trees and bushes, so here are a few forms for you to practise. They are designed to be sketched rapidly to capture essential shapes and character – there's no need to spend time on fine detail.

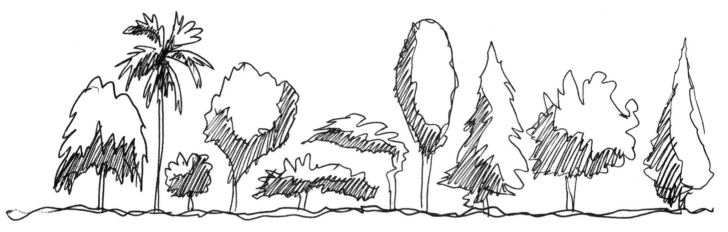

Basic tree shapes (biro).

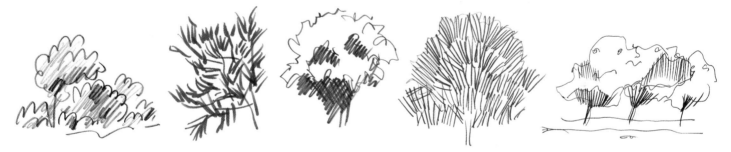

Shrubs and bushes (left to right): woodless graphite, grey felt pen, HB pencil, HB pencil, biro.

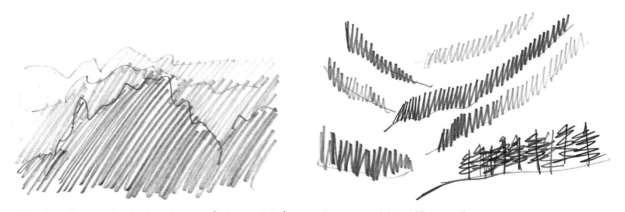

Blocks of trees in the landscape (left to right): woodless graphite, HB pencil.

You can sketch blocks of trees in the landscape as bands of tone, as in these examples of aerial perspective where the foreground trees are shaded in darker tones. The strips of conifers on the mountain slopes (above right) are sketched simply as vertical zigzags, with foreground trees rendered in more detailed horizontal zigzags.

10-minute sketch: trees

Now, take your pick of trees to sketch!

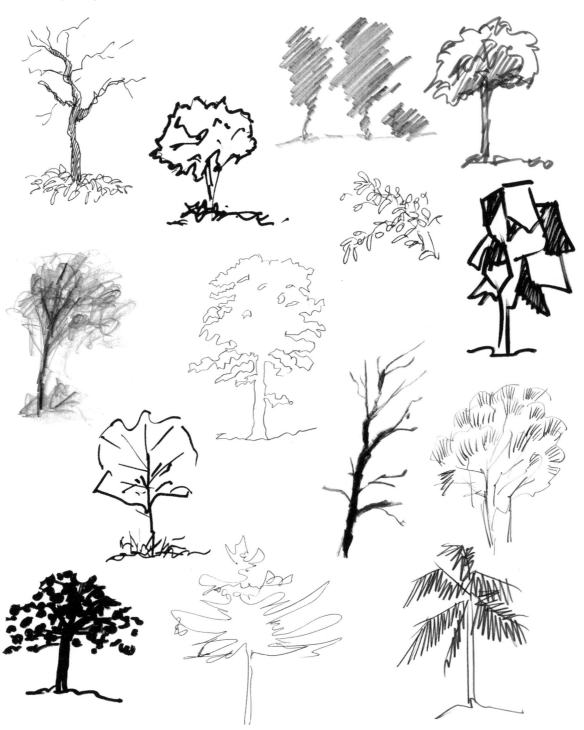

Left to right, top to bottom: bare branches (biro); bushy tree (fountain pen); graphite shapes; shaded tree (grey felt pen); graphite scribble; HB pencil outline; biro leaves; geometric tree (marker pen); circular tree (fountain pen); leafless trunk (charcoal); fan strokes (HB pencil); blobby tree (marker pen); fineliner pen outline: palm tree (HB pencil).

Landmarks

By now you will have experimented with different styles and media and become more familiar with various techniques. If you have a range of media with you when sketching landscapes, you can consider which of them may suit a particular subject. For example, smudged charcoal is ideal to create a soft, atmospheric and misty effect, biro suits a metal statue, felt pen and graphite are good for softer tones in a landscape and bold black marker pen conveys the power of a striking monument.

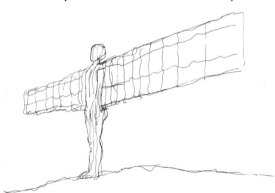
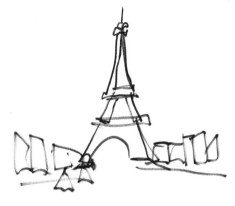

Left: the Angel of the North, Gateshead (biro); right: the Eiffel Tower, Paris (blind sketch in marker pen).

Here simple lines and outlines capture the shapes of two famous landmarks. It's fun and challenging to try sketching blind and you'll be pleasantly surprised at how good a likeness you can achieve.

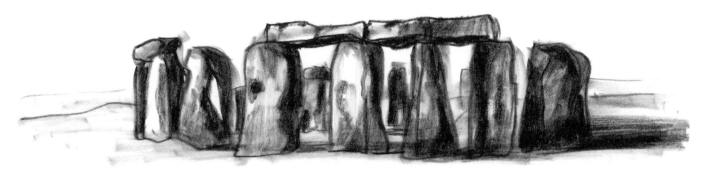

Stonehenge (smudged charcoal).

Outline the basic stone shapes, partially fill with lighter, mixed tones, then add dark shadows. Use horizontal strokes for the ground, then smudge lightly.

Concentrate on sketching the overall shapes and features and don't worry about complete accuracy.

Avington House portico (HB pencil) and church (biro).

Skylines and skyscapes

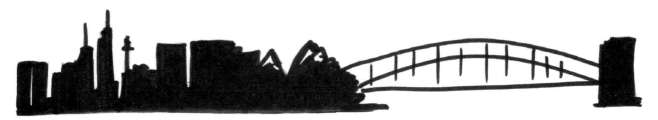

SKYLINE SILHOUETTE *(marker pen)*

An interesting way to record a landscape, particularly a cityscape, is to create a skyline. Simply sketch a contour by simplifying the shapes, then shade as a silhouette.

SUNSHINE OVER THE BAY
(woodless graphite)

To create this sunny sky, use the side of the lead to horizontally shade the top half from dark to light, working from top down to middle, then smudge with a tissue and lift out the white clouds with an eraser. Use a thin, dark line to create the strip of land on the horizon. Then create delicate, smooth, soft tones in the foreground with the side of the lead. Add a few light horizontal strokes and, for more highlights, erase other areas in the foreground.

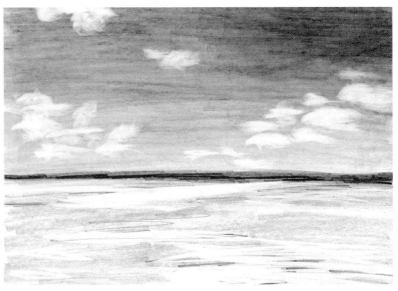

STORMY SKY *(charcoal)*

This was inspired by John Constable's sketch *Seascape Study with Rain Cloud* (c.1824–28). Go wild with bold charcoal strokes to capture the mood of a dramatic, stormy sky.

Landscapes

You will probably encounter many different landscapes on your travels, so here are just a few samples to inspire you to fill your sketchbook. Notice the different effects you can achieve with different materials, such as the atmospheric mountain Helvellyn captured in grey felt pen and graphite and the hard, rocky outcrop of Great Close Scar depicted in fineliner pen. The beauty of sketching landscapes is that accuracy isn't critical, and it doesn't matter if a tree is the wrong shape or slightly out of place.

Mountains and rocks

STRIDING EDGE, HELVELLYN, CUMBRIA *(grey felt pen and woodless graphite)*

Outline the main ridge contours and landscape features such as the rocky outcrops in graphite and add dark and medium-toned shadows. Then use the side of the felt pen nib to add streaks of pale grey to subtly emphasize the landscape forms.

GREAT CLOSE SCAR, PENNINE WAY, YORKSHIRE DALES *(fineliner pen)*

This drawing is in the style of Alfred Wainwright (1907–91), famous fell walker, author and illustrator. Use a fine nib to outline the craggy outcrops, then directional strokes of varying lengths to highlight crevices, screes and loose rocks.

Rural vistas

You'll see from these examples sketched in different styles how a few rough strokes and simple details can be used to create delightful and evocative rural scenes.

SHEPHERD'S LANDSCAPE
(woodless graphite)

This landscape is in the style of Thomas Gainsborough's sketch *Shepherd and his Flock* (1775). Use bolder outlines to describe the land forms and clumps of vegetation, then add shadows in dark sketchy strokes. Create aerial perspective with dark foreground tones and paler tones in the distance.

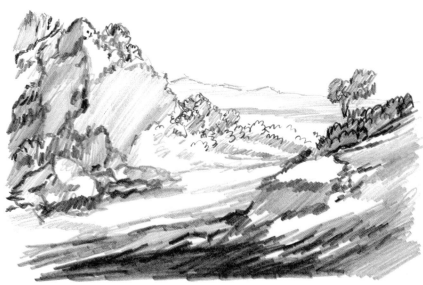

THATCHED COTTAGE 1
(HB pencil)

The sketch on the left was inspired by John Constable's *Cottage in a Corn Field* (1817). Sketch with light, medium and dark-toned scribbled strokes, leaving some areas blank to denote bright sunshine. Use both linear and aerial perspective.

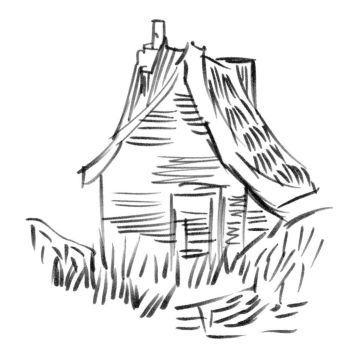

THATCHED COTTAGE 2
(grey felt pen)

The line drawing on the right is after Vincent Van Gogh's sketch in one of his letters. In both of these cottage sketches, use directional strokes to create different features and textures, following the contours of each subject.

Water

In the first three examples below, water is portrayed by gently swirling strokes.

SEASHORE *(biro)*

My reference here was *Fishing Boats on the Beach* by Van Gogh (1888). Use loose, quick strokes to depict the curved shapes of the foreground boat and distant sails, S-shaped swirls for the shoreline and small circles for the beach pebbles.

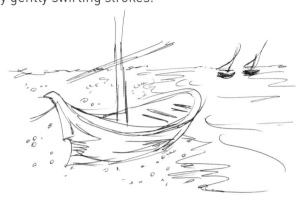

GOLDEN GATE BRIDGE, SAN FRANCISCO *(grey felt pen)*

Sketch three rectangular shapes for the bridge uprights and deck and gentle loops for the supporting cables. Use a couple of horizontal lines to suggest the distant horizon and a simple squiggle shadow under one of the uprights to imply water. Leave the rest of the broad expanse of water blank.

HARBOUR SCENE *(fineliner pen)*

Sketch this busy scene in pen and ink without trying too hard to get perfect detail or accuracy. Put in a few lines to suggest the geometric shapes of the buildings and bustling harbourside and sketch simple outlines to describe the two boats in the foreground. Use scattered, short, wavy horizontal strokes to depict the water and denser strokes for the shadows.

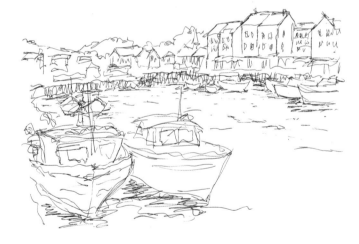

FISHERMAN'S ROPE *(woodless graphite)*

Capture this section of coiled rope by shading lengths of interwoven S-shapes in light and medium tones between pairs of parallel lines. Use dark tones for the shadows in between.

LAKE AND TREES *(woodless graphite)*

This view of a lake with a wooded shoreline in the foreground requires you to use aerial perspective and negative shapes as well as sketching an assortment of vegetation in a range of tones.

STEP 1

Within a rectangular drawing area, lightly outline the main features of the landscape – the triangular peninsulas along the shoreline, the distant hills and the tall tree trunks.

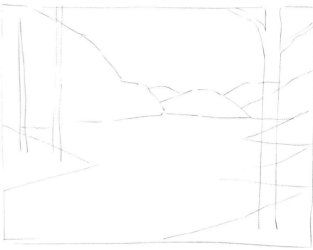

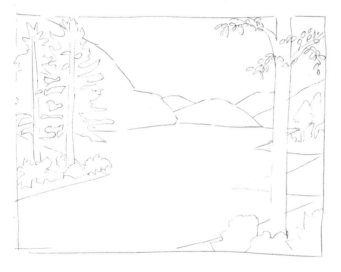

STEP 2

Lightly outline areas of tree and ground foliage then erase any 'land' outlines from the tree trunks and foliage.

STEP 3

Using aerial perspective, fill in the land areas (lighter tones in the distance progressing to medium and dark tones in the foreground). On the distant hills, use sketchy strokes that radiate downwards and outwards from each summit. Take care to draw around any negative shapes, for example in the foliage. Add a small strip of darker tone along the distant shoreline.

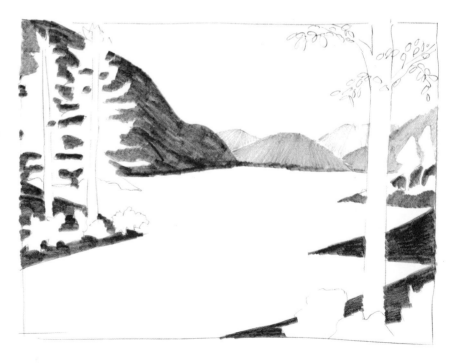

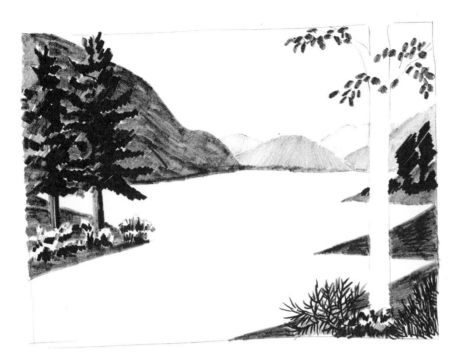

STEP 4

In medium and dark tones, complete the foliage in a little more detail, following the examples on pages 59 and 60 if necessary. Create shadows on the foliage and tree trunks on the left side of the scene (in this example, the light source is from the left).

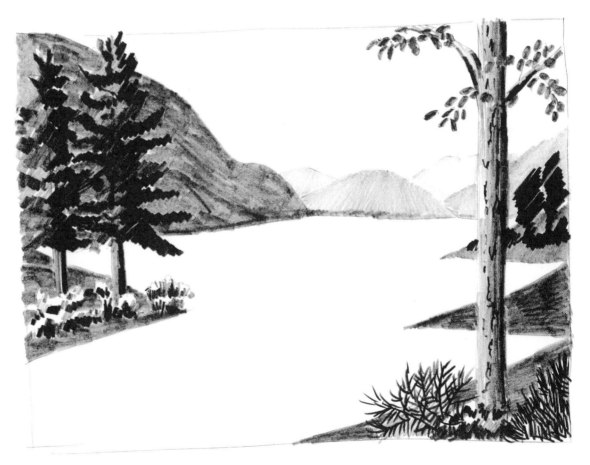

STEP 5

Complete the tree trunk on the right using graduated tones from light to dark (left to right). For texture, add small random marks to the trunk.

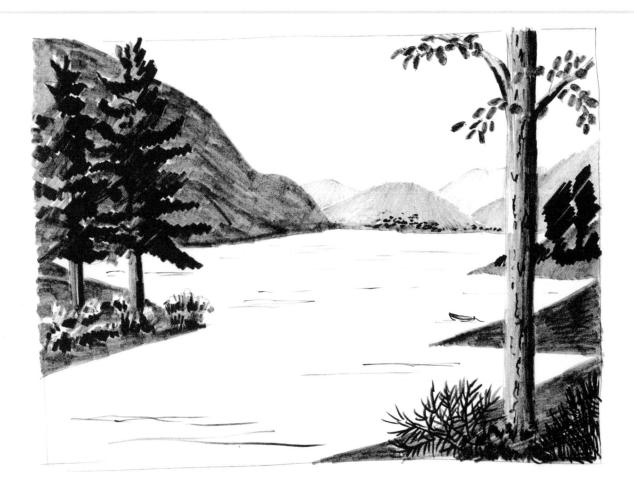

STEP 6

If necessary, lightly shade over the ground vegetation to fill in any unwanted background gaps. Add a few tiny shapes to the distant hill to create the impression of buildings (see inset). Leave the lake blank except for a few horizontal

lines to indicate the water surface, making the nearest lines darker. Add a small boat in the mid-foreground (see inset). If you like you can neaten up your final sketch by cropping the edges.

Common errors

Scribbled foliage

Rather than use random scribbles to fill areas of leaves and vegetation (left), sketch clusters of leaf-like shapes instead (right).

Poor perspective: spot the difference

Creating the correct perspective may seem perplexing, but if you follow the guidelines on pages 33–37, you will soon become proficient. To help jog your memory, play 'spot the difference' with these two images. How many perspective errors can you find in the top image, when compared with the correct image below it? The answers are on page 128.

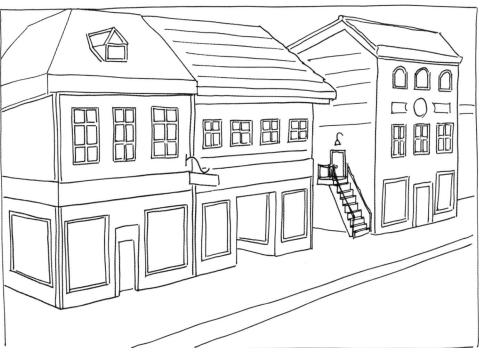

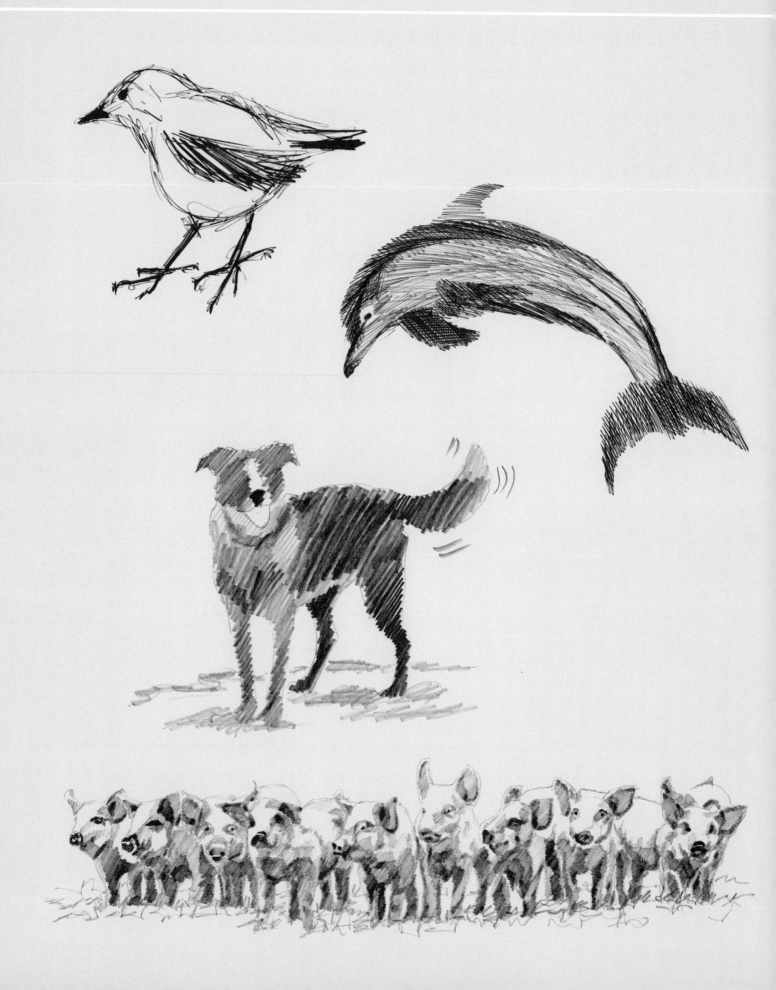

Chapter 4

ANIMALS

For millennia, animals have been an integral part of the culture of the human race. Today, whether we admire them in the wild, rely on them economically or simply enjoy their companionship, they remain a fascinating subject for artists.

In the previous chapters most of the subjects you sketched were inanimate, but now you'll take up a new challenge and tackle subjects that won't necessarily stay in place while you draw them at a pace you choose. However, beginning with small, uncomplicated sketches will help you to progress to more detailed and taxing works without too much difficulty.

The subjects range from insects to large mammals and from stylized pets to realistic wild animals, but you'll still be using the same basic techniques and simply applying them in different ways. You'll have great fun exploring a few different approaches to capturing animals on paper and whatever your level of ability when you start you'll be surprised by the strides you make.

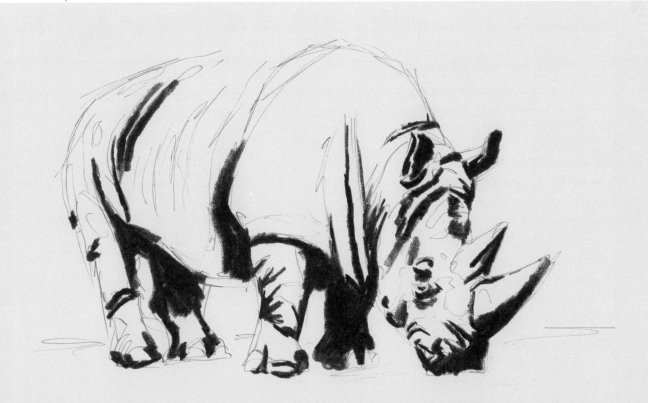

Where to begin

You'll find animals all around to inspire you – even insects that may never have attracted your attention before! Your first consideration is the amount of time available to sketch; for a fast-moving subject, your sketches will need to be quick impressions unless the animal is sleeping or performing repetitive actions.

When sketching a live subject, focus on capturing a likeness or attitude and the most expressive or characteristic features such as an overall shape or arrangement of limbs. If you can establish proportion and gesture, then your impressions will really come to life – you can always add details and tones later. Likewise, you can hint at backgrounds with simple lines, or take reference photographs for later use.

If sketching from life seems a bit formidable at first, practise from a reference photograph and allow yourself 20 seconds to capture a pose before starting on another. This is a great way to develop your skills. Photographs are also an invaluable source of reference when you want to draw a fish, insect, bird or other wild animal which won't stay obligingly close to you in the way that a domestic animal such as a cat, dog or horse will.

It can help to have an idea beforehand about how you'd like to proceed in terms of size, style and so on, but don't worry if you change your mind halfway through and your sketch develops into something else – this is all part of the creative process and often brings delightful surprises.

It's best to start with just one animal in each sketch rather than be overly ambitious and attempt a sketch that has too many subjects, is very big or has a lot of detail. You risk becoming disheartened and abandoning an unfinished work because you have run out of time, skill, or inspiration (as I did with this sketch of a dog many years ago).

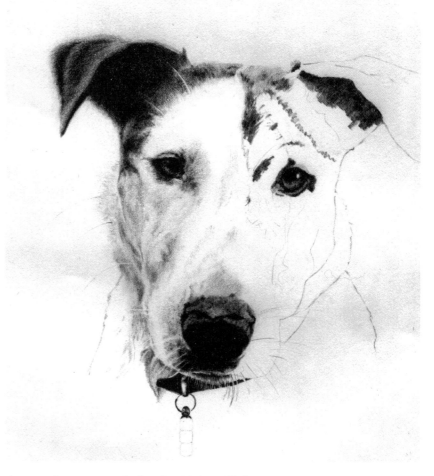

Attempting too much detail with insufficient resources and time resulted in a discarded and unfinished sketch.

Small animals

Small animals are much more common than most of us realize. In fact, insects account for 90 per cent of all animals (over six million species) and half of all living things on our planet. The beauty of drawing small animals is that they can be quickly and easily sketched.

LADYBIRD *(biro)*

Some of the smallest creatures are familiar insects and we begin with this easy-to-sketch ladybird. This species is definitely a gardener's best friend because ladybirds (or ladybugs) eat aphids.

STEP 1

Lightly sketch the shapes; they are mostly elliptical.

STEP 2

Shade the wing case and spots in dark and medium tones.

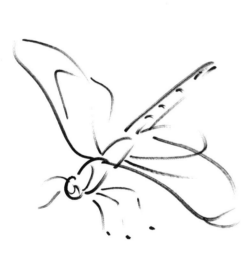

DRAGONFLY *(marker pen)*

Did you know it's considered good luck if one of these shimmering animals lands on your head? Use quick strokes to partly outline the head, wings and long abdomen, then add a hint of legs, feet and antennae.

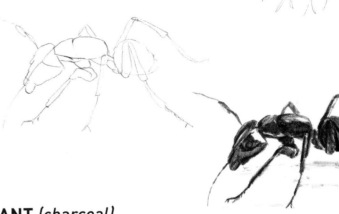

ANT *(charcoal)*

Ants live in complex colonies, can carry 50 times their own body weight in their jaws, and started farming 70 million years ago, long before humans. This is an unusual but easy and satisfying subject to draw. I observed an ant while it was feeding, then when it moved on I used a photograph to clarify details.

STEP 1

Sketch three ellipses for the head, thorax and abdomen then add rectangle shapes for legs. Refine the details.

STEP 2

Shade in dark, medium and light tones, leaving the highlighted areas blank.

Aquatic animals

Water in all its forms is home to a huge variety of aquatic animals, from microscopic fish to our largest mammal – the whale. Fish are particularly easy to sketch because of their simple cylindrical shapes which taper at each end. Other creatures such as crustaceans make fascinating studies because of their interesting anatomy and textures.

CRAB *(HB pencil and grey felt pen)*

All crabs have one pair of pincers and four pairs of walking legs (so are classed as decapods). I used pointillism to complete this example because the effect looked like grains of sand – the natural habitat of many crabs.

STEP 1

If it helps you to gauge the proportions, use an HB pencil to lightly draw the rectangular area of the sketch and divide it into quarters before outlining the main crab features in pale strokes.

STEP 2

Erase unwanted pencil marks. Use the felt pen to fill the crab with dots of different density, making much denser dots in areas of deep shadow such as at the claw joints and eyes. To add greater realism and create volume, make slightly denser dots overall on the right side of the main shell. Once you have completed the crab, fill the surrounding area with widely spaced dots to represent sand, with patches of denser dots for shadows and small stones. You may want to erase any remaining pencil marks.

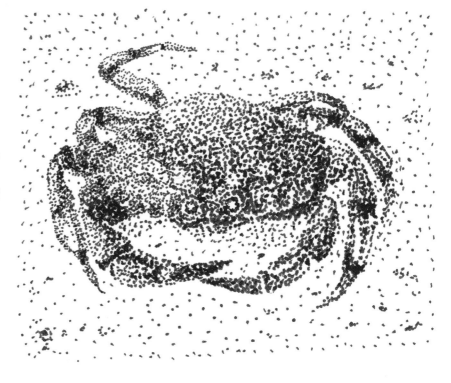

LEAPING SALMON *(woodless graphite)*

Salmon migrate from the ocean to the upper reaches of rivers to spawn and as they journey upstream they may be seen leaping out of the water. This depiction of a salmon leaping a small waterfall has more background detail than the previous sketches.

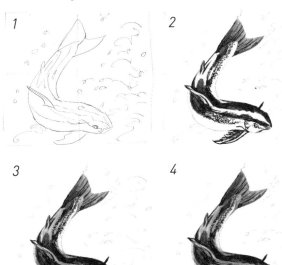

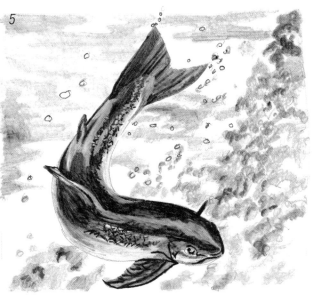

STEP 1
Lightly outline the fish and areas of water.

STEP 2
Shade in the darkest tones.

STEP 3
Add the medium tones.

STEP 4
Shade in the light tones.

STEP 5
Add the background river as smooth, horizontal strokes. Sketch the foreground water droplets and spray in blobs of dark, medium and light tones, then smudge.

WHALE *(grey felt pen)*

See if you can contour sketch this whale's tail in a single line without lifting your pen off the page.

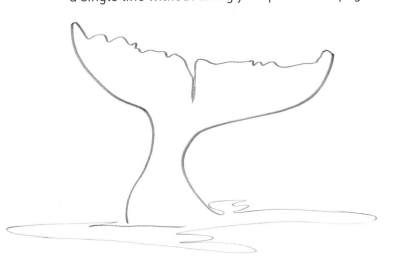

DOLPHIN *(biro)*

It is thought that dolphins leap out of the water to communicate with other dolphins, to play, and to locate food and predators. Complete this dynamic mammal with directional strokes of different density, following the contours of the body. Use cross-hatch strokes for the nose, head, fins and tail.

Birds

Most birds are shy except perhaps a cheeky robin in the garden, so it's not often we have the chance to sketch them at close quarters.

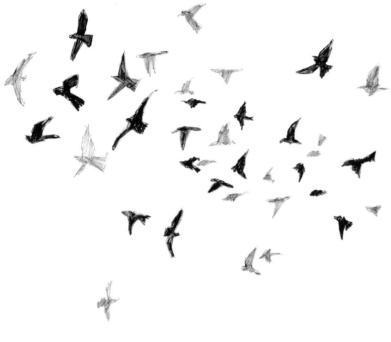

FLOCK OF BIRDS *(HB pencil)*

Birds may be the hardest of all animals to capture on the page because they move so quickly, especially when flying – you may need to resort to reference photographs to sketch them in more detail. First, practise sketching them in motion. This flock of birds uses aerial perspective – the more distant birds are smaller and paler than those in the foreground.

Note the angles and shapes of the wing and tail feathers as you sketch. Seen in greater detail, it's easier to work out the geometric shapes.

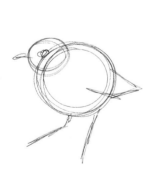

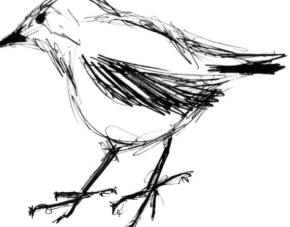

ROBIN *(HB pencil)*

This started out as a blind sketch, then I completed it by looking at the paper as I added details to the feet and beak. The thumbnail shows the basic shapes.

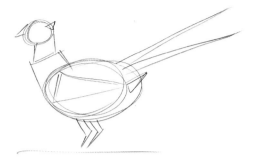

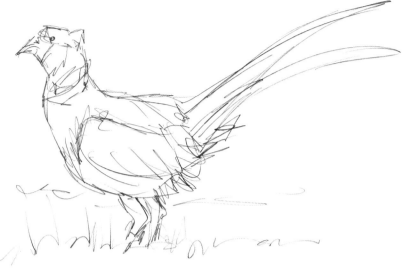

PHEASANT *(HB pencil)*

You will find pheasants in woods, scrub, swamps, grasslands and areas near farms. Sketch this game bird in pencil strokes, referring to the basic shapes in the thumbnail if required. Add a few horizontal squiggles to give a hint of background.

ROOKS *(marker pen)*

Rooks are members of the Corvidae family, which also encompasses crows, ravens, magpies, jays and other familiar species. Rooks live in colonies, form long-term monogamous pair bonds and eat predominantly earthworms and insect larvae. Try this sketch in black marker pen, which suits the stark contrast of the black rooks and bare branches silhouetted against the sky.

Domesticated animals

It is thought that the first livestock to be domesticated were goats, around 11,000 years ago, followed by other animals such as chickens and sheep. It is generally easier to draw domesticated animals because they will tolerate human company more readily than their wilder cousins and this gives you extra time to sketch a pose. If they are in an enclosure you'll often have the chance to return for more practice – a horse in a field will tend to be available as a model day after day, for example. Here we look at some well-known species.

CHICKEN *(fountain pen)*

Have a go at creating this magnificent strutting cockerel in one continuous line. You may find it helps if you imagine the subject as you sketch, for example, its character, the texture of the plumage, its scent or how it moves.

PIGLETS *(HB pencil)*

It can seem a formidable task to draw a group of animals such as this litter of piglets. The best ways to approach it are to make a lot of mini sketches of individual animals and

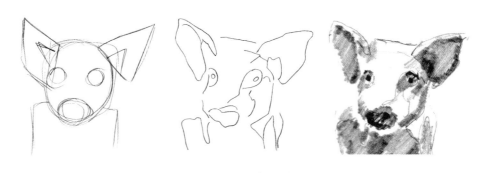

create a montage or simply take a photograph. Once you break the sketch down into manageable sections or even individual animals, you'll find it much easier. Identify and outline the overall shapes (inset) such as the ears and legs as well as the main areas of dark and light tones. Use very dark

tones to add key features such as the eyes and nose, and medium tones for the ear edges. Roughly fill the remaining areas with medium and light-toned diagonal strokes. Leave some areas blank as highlights.

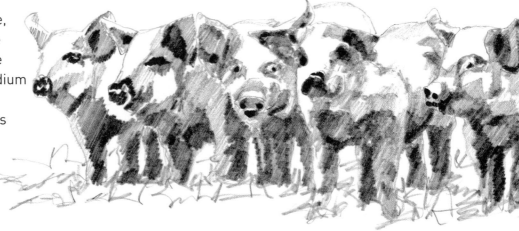

GOAT *(biro)*

Goats are incredibly agile and very sure-footed tree-climbers. This sketch of a goat perched on a branch in a leafy argan tree may look complicated because of the jaunty angle of the animal, but most of the basic shapes of a goat are rectangles (see thumbnail). Once you've constructed these shapes, gently lighten the construction lines with an eraser so they don't show in the final piece and adorn the framework with simple scribbly pen strokes to complete the goat. Add a few branch and leaf scribbles as a background.

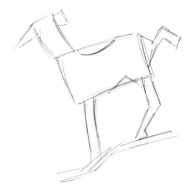

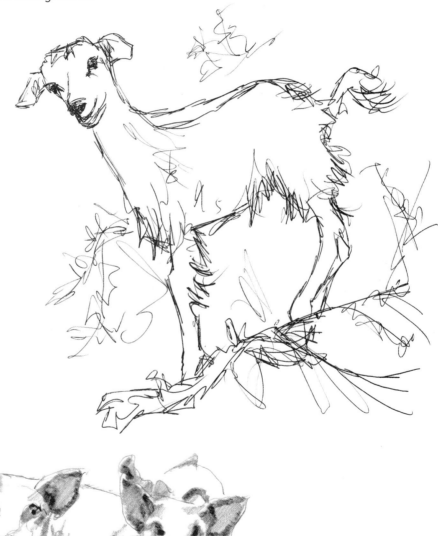

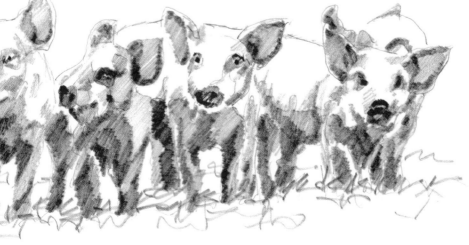

MUCKLE COO
(HB pencil and charcoal)

The muckle coo, or Scottish Highland cow, is sketched here in cubist style with the emphasis on the formal structure and complex details reduced to simple geometric forms. This cow has the longest coat of any cattle breed and it's an unusual double coat that protects them from the harsher elements.

To draw this cow, outline the overall shape in HB pencil, then use your imagination to sketch the features in bold geometric shapes in charcoal.

HORSE *(HB pencil)*

Working horses were a common sight in the not too distant past and you can still find some today, especially in the forestry sector. However, the equine world now mainly consists of riding schools, trekking centres, breeders and events. Try this head and shoulder study rendered in diagonal strokes and note the predominance of diamond and triangle shapes in the outline sketch.

STEP 1
If required, outline the main shapes to help establish the correct proportions.

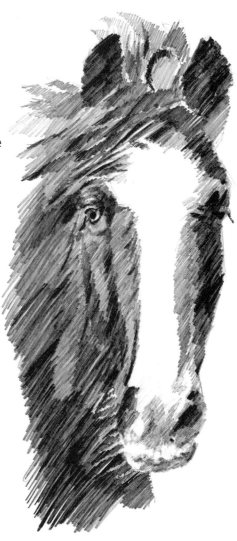

STEP 3
Fill the areas of tone in a mix of light, medium and dark shades, referring to the inset for more details of the eye area.

STEP 2
Use faint lines to depict the main areas of tone.

Pets

As they share our lives, pets are popular animals to sketch and many people would like to be able to make a good drawing of their own pet in particular. Here we look at three companion animals portrayed in different styles. You'll complete some of these examples in minutes, while the step-by-step exercise overleaf will require more patience.

While it's easy to draw a generic cat or dog, you need keen observation skills to capture a particular expression, tilt of the head, or attitude of the tail – the things that make an animal, perhaps your own pet, unique. Then you must put these features in proportion in exactly the right location on the page – something that gets easier over time. When sketching from life, you'll find it easier to sketch sleeping pets, and dogs especially may obediently pose for you. If you don't fancy drawing a whole animal or a head and shoulders portrait, you could focus on a specific feature such as an eye. Alternatively, if you'd like to complete a more detailed study it may be best to work from a photograph.

10-minute sketch: pets

CATS

Here's your chance to test your skills and use minimalist lines to rapidly sketch these cats. Don't worry if you think your first attempts are not very good – you will improve with practice.

WAITING (marker pen)

Apply quick, bold and confident strokes to portray the essential shapes of this sitting cat and allow your eyes (not your thinking mind) to guide your sketching hand.

WATCHING (HB pencil)

To create this effect, first sketch the outline, fill with random scribbles, then erase any lines that fall outside the outline.

SLEEPING (grey felt pen)

Aim to simply sketch the basic shapes without adding unnecessary detail. Notice the overall elliptical shapes of the cat's body and head and how you can describe some features such as the closed eyes and nose in single strokes. Cats' ears are particularly characteristic, rendered here in two or three lines.

HAMSTER *(biro)*

The idea of this quick scribble is to just sketch without thinking too much and to let your subconscious do the drawing. Simply start scribbling, with no outline, using varied pressure and stroke density to achieve the lighter and darker tones. Don't be too concerned if it turns out a bit wonky!

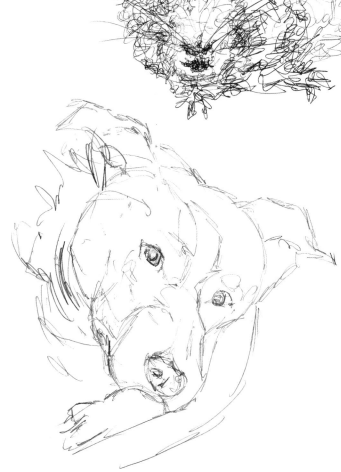

DOGS *(HB pencil and biro)*

Now have a go at these examples of a dog with its head resting on a cushion (the type of sketch you would make from life when the dog may not be still for long) and a contour sketch of a dog with a collar, made from memory. Don't worry if your memory is not always accurate, especially if parts of your sketch like the collar here are a little out of place, but do congratulate yourself if you achieve an overall resemblance. If you find some angles and shapes awkward to draw, try drawing the darks and lights instead. Half-closing your eyes will help you to see the proportions and angles a little better.

'MIST' THE BORDER COLLIE
(woodless graphite and HB pencil)

This sketch is broken down into steps to show you how to accomplish a dog portrait with a semi-detailed background. I used linen-textured card to allow the pencil to adhere to the surface and create more texture, woodless graphite for soft background detail and HB for the darker, finer, dog details and foreground vegetation. Graphite smudges easily, so I completed the dog as the last step.

STEP 1

Outline the main features (the areas of dark and light tones).

STEP 2

In graphite, use medium and dark tones to fill the soft-edged strips of background vegetation on the mountain. Gently sketch pale horizontal tones for the middle-distance vegetation. Note how the dog becomes a negative space.

STEP 3

Use light tones to fill in between the darker strips of vegetation, then an HB pencil to begin shading the outline of the dog. Leave the neck areas blank to indicate white fur.

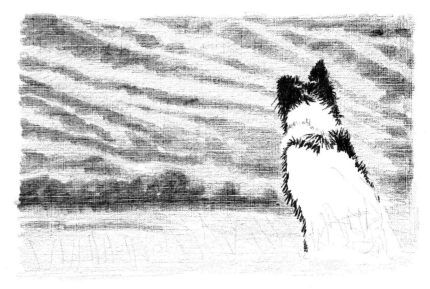

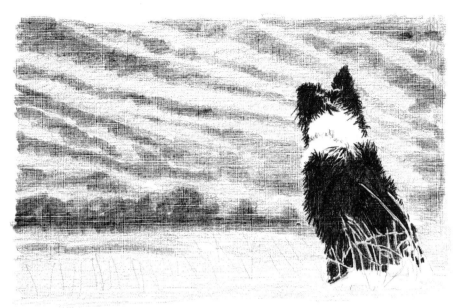

STEP 4
Complete the finer dog fur details in HB, drawing around the grass stalks – it's easier to do this than erase later.

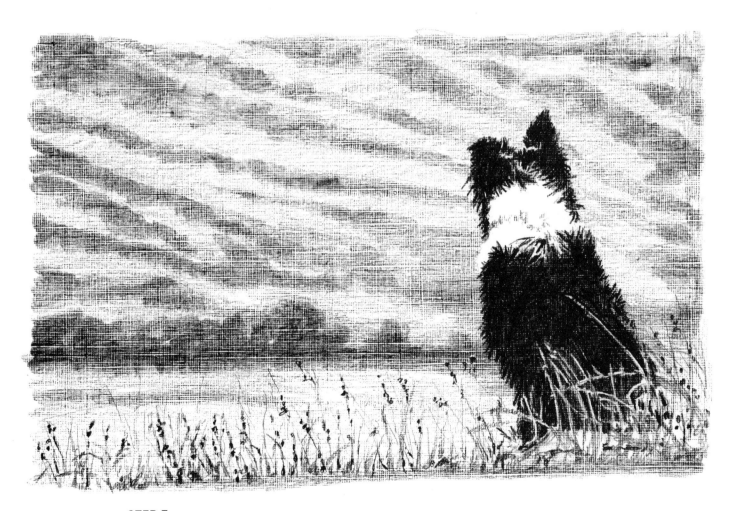

STEP 5
Finally, add the intricate grass stalks and seed heads in HB and complete the foreground vegetation in graphite.

Wild animals

Wild animals can be fascinating but are often shy and elusive and thus challenging to sketch as you may see them for only a few moments before they move or disappear altogether. Unless the animals are sound asleep, you will need to perfect your rapid sketching skills or rely on your memory or photographs to sketch these animals! Alternatively, you may have time to sketch detailed poses in some wildlife sanctuaries where the animals are more tolerant of people and less likely to move away.

CHIMP *(HB pencil, fineliner pen and marker pen)*

Chimpanzees are our closest living relatives, and this pose certainly shows the very human-like qualities of contemplation and observation. This detailed pen and ink sketch requires more advanced skills and quite a bit of time to complete. This sketch was based on a photograph, which was essential to achieve the correct proportions at the start.

STEP 1

Lightly sketch the main features and areas of darkest tone in HB pencil. Notice how few guidelines are required, but their correct placement is essential. When you are happy with your guidelines, you can start to add pen and ink detail.

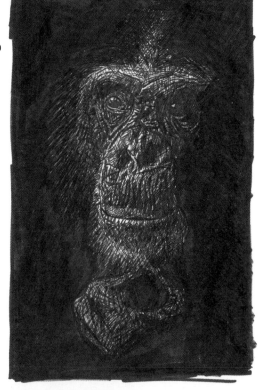

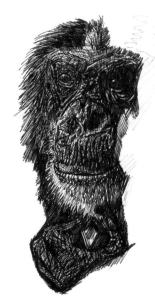

STEP 2

Use a fineliner pen to create the features with a mixture of cross-hatch strokes and thick lines (see inset, right). Use denser strokes to create areas of shadow. Leave the highlighted areas blank.

STEP 3

Fill the plain background as solid black, using either a fineliner pen or marker pen.

RHINO *(charcoal)*

The rhinoceros is one of the world's top ten largest and heaviest land animals and your drawing should convey its bulk. This example is almost the opposite of the chimp, being mostly white with a few dark lines. I was going to add paler tones but changed my mind halfway through and decided it looked fine as it was.

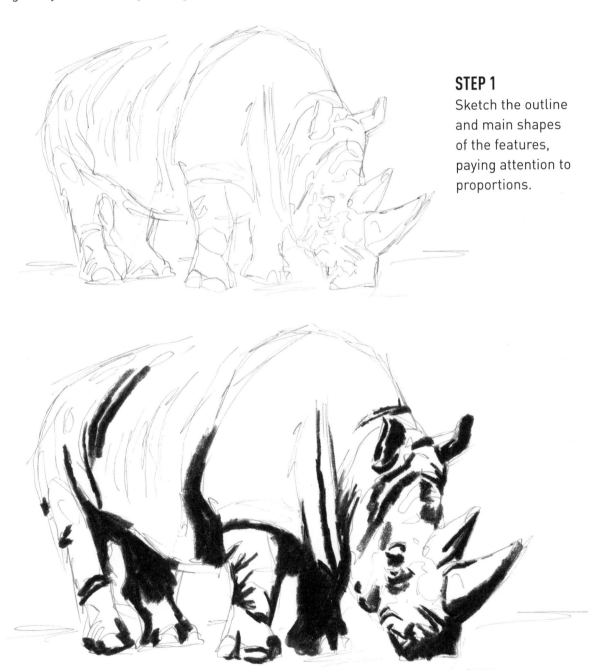

STEP 1
Sketch the outline and main shapes of the features, paying attention to proportions.

STEP 2
Add the darkest tones for the skin folds and areas of shadow. Leave the sketch there or, if you like, emphasize the other lines with lighter tones, or fill for a different effect.

Capturing motion

It's hardest to sketch an animal when it's moving as you need to get the shapes right and give the impression of motion, though your model won't wait for you to study how to do that! Here are a few ideas, all done in HB pencil.

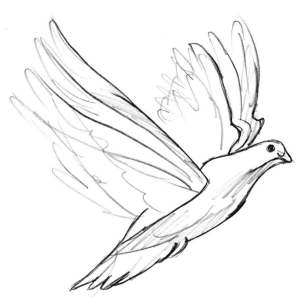

CAT WALKING

Sketch a moving animal, using sinuous lines and leaving a few gaps in your outline to imply motion.

FLYING DOVE

Sketch the same part in several overlapping positions, as I have done with these wings.

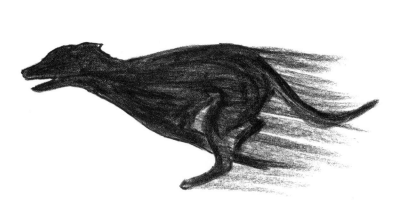

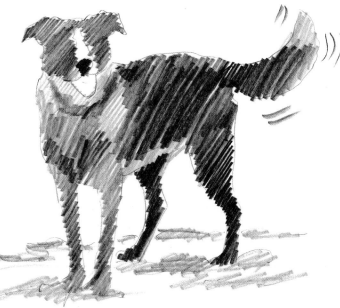

RACING GREYHOUND

Use sharply delineated features at the front and blurred lines at the rear, with trailing streaks to imply even more speed.

WAGGING TAIL

Short curved marks around the tail suggest movement from side to side.

Test your observational skills

These silhouette shapes may challenge your perceptions – can you identify the four animals?

Answers: Clockwise from left: horse, crab, piglet, cat (see drawings on pages 81, 74, 78 and 82). You will notice that a familiar animal may look very different as an outline shape or silhouette, but if you look closely you may see that a characteristic feature such as an ear (on the piglet and cat) or limb (crab) can give you a clue as to the identity.

Common errors

Attempting too much risks disappointment when you run out of time and cannot finish or realize you have ruined your work through trying to hurry.

Looking down on an animal when you take a photograph foreshortens the image and the animal will look distorted. If possible, take photographs at the animal's eye level or move away slightly to get a better camera angle.

Using a flash when taking photographs of animals means the features tend to look unnaturally flattened. It's best to photograph animals outdoors in natural light.

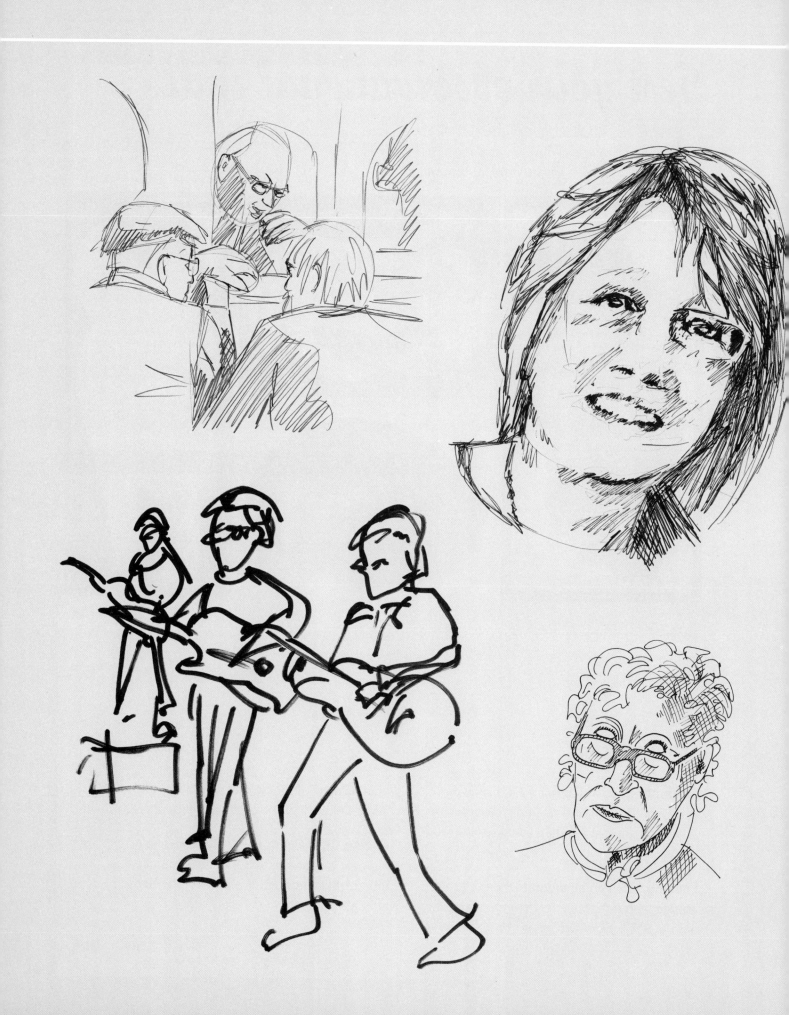

Chapter 5

PEOPLE

'I can't draw people' is something I've often heard, but a sketch is simply about capturing a moment in time – an impression, emotion or memory. You won't have enough time to be very accurate, but if you enjoy the experience of observing and sketching people this will show in your work and, as with all skills, the more you practise, the better your sketches will become.

We are constantly in the presence of other people wherever we go, so we think we know what they look like. However, when we come to sketch them we may struggle to produce a likeness. Most people won't notice if we sketch a hill or a tree slightly out of place in a landscape, but a face will look completely different if we misplace the features a bit or make them the wrong size. This is where your practised observation skills will come to your aid as you look at what is actually there and not what you think you see in your mind's eye.

Coffee shops are a great place to start because people are likely to be sitting still for a while and you'll be comfortable, with a table in front of you to rest on. You can also sketch (albeit in a slightly wobbly fashion) while travelling by train or bus. Inspiration for sketches can also come from holiday snaps, friends and family – and of course you can always sketch yourself in front of a mirror.

For a while I was a reluctant people-sketcher after one of my first portrait sketches was not liked by its recipient. Your subjects may hope to appear younger, better-looking or slimmer than the reality and it can be off-putting if your early attempts don't please, but it doesn't necessarily mean you've gone wrong! In this chapter we'll look at proportions and how to get up to speed sketching people, then explore how to show different ages and try different techniques.

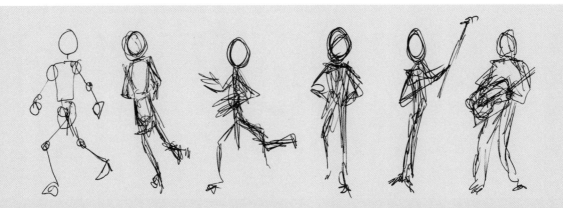

Easy stuff

If you can draw this circle and 11 lines, you can certainly draw a stick person because the stick person is assembled from the 12 pieces!

Here's another easy way to create a stick person. Practise by using pictures of people, for example in old photographs, and simply draw lines and shapes (for head, body and limbs) over the pictures. This way, you'll become familiar with sketching different body shapes and proportions.

You'll soon be able to create different postures, especially if you practise sketching from life or from magazines and the television. It's simple and fun and you can see from these figures how to add extra detail by simply adding more scribbled lines.

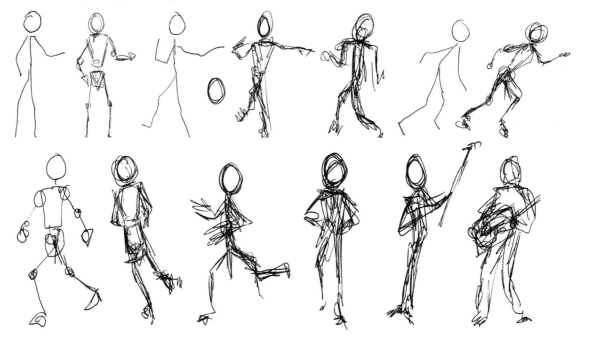

Gesture drawing (drawing a series of poses in quick succession) is great practice if you're rusty. Allow yourself 10 seconds or a minute to sketch the same subject in different attitudes, one after the other.

You can also sketch *blind* by continuing to look at the person as you draw without looking down at the paper. It's a good way to practise sketching people of different ages and sizes without worrying too much about accuracy; you'll surprise yourself with your results.

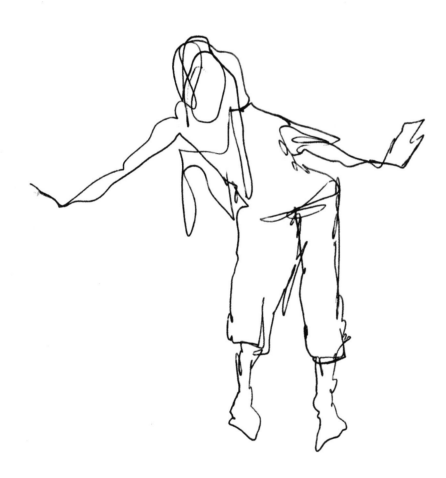

Blind sketches: woman, baby boy, young girl with football.

Proportions

Once you've become confident about sketching stick figures, it's time to think about the practicalities of sketching a real person. While people come in all shapes and sizes, their proportions are relatively standard. An adult's height is roughly seven to eight times the length of their head; a child's five to six, and a baby's three to four.

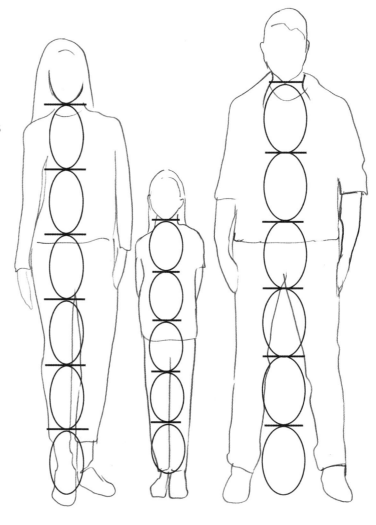

Heads and faces

The human head is more egg-shaped than round. Men's features tend to be more angular than women's, particularly around the jawline. While the heads of children and babies are larger in relation to their bodies compared to adults, their faces are smaller in relation to their heads. From the brows down a baby's face occupies only about a quarter of the area of the head. You can see these differences in the profile views of the man, woman, young child and a baby.

SKETCH A SIMPLE FACE AND HEAD

Of course people's facial characteristics vary, but once you have mastered the standard proportions of a simple face you can adapt them to draw individual faces.

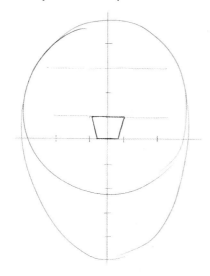
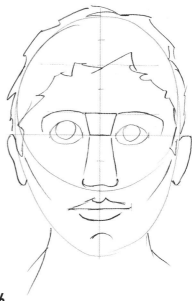

STEP 1

Draw a circle, then extend it to create an egg shape.

STEP 2

Divide it into quarters; the horizontal line is the eyeline, halfway down the face. Divide the vertical line into ten equal sections, and the horizontal line into fifths (this is five eye-widths).

STEP 3

Draw a faint horizontal line at the two-tenths mark (this is the hairline) and a similar line at the four-tenths mark (this is the brow line). Sketch a keystone shape in the middle between the brow and eye lines.

STEP 4

Sketch the eye shapes on the eyeline, one eye-width apart. Add an incomplete circle for the iris in the middle of each eye (the top of the iris is partially concealed by the upper eyelid).

STEP 5

Draw the eyebrows on the brow line, curving them outwards and downwards at the ends to give the shape of eye sockets.

STEP 6

For the nostrils, draw a line one eye-width along the seven-tenths line. Extend lines from the keystone down to the outer edges of the nostrils.

STEP 7

Now draw the centre mouth line along the eight-tenths mark and align the edges of the mouth with the centre of each eye. Add the upper and lower lip lines.

STEP 8

Mark the chin on the nine-tenths line.

STEP 9

Sketch the ears between the eye and nose lines.

STEP 10

The hair sits around the circle, not directly on it.

STEP 11

Sketch a hint of cheekbones along the line from the top of each ear to the chin.

STEP 12

Draw the neck lines, which roughly align under the outer edges of the eyes.

10-minute sketch: heads and faces

Now you're equipped with a grasp of basic proportions, try sketching different people. Look for key features and sketch these first – usually the darkest tones and dominant lines and angles. Add more details and tones if you have time. When capturing expressions observe the eyes and mouth, which move more freely than other parts of the face. Here are some suggestions of styles you might like to try.

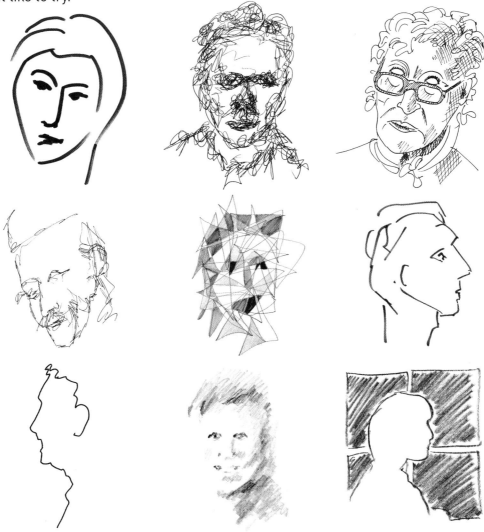

Left to right, top to bottom: **Minimalist 1** *(marker pen): The challenge is to draw a face with as few strokes as possible.* **Scribble** *(biro): Use random scribbled strokes to sketch the main features and don't worry too much about accuracy!* **Cross-hatch** *(fountain pen): Create more volume by adding cross-hatch lines to a line drawing. Keep the cross-hatching to a minimum and vary the direction of the strokes.* **Blind sketch** *(biro): Sketch without looking at the page.* **Abstract geometric** *(HB pencil): Create a random patch of lines and just fill in a few shapes in different tones.* **Minimalist 2** *(grey felt pen): Try sketching the face from a different angle, using just a few lines.* **One-line** *(fountain pen): Draw the profile with a single, continuous line.* **Tonal** *(woodless graphite): Without guidelines, use the flat lead to shade areas of tone.* **Silhouette** *(charcoal): Use negative space to outline and highlight your subject.*

Expressions

Here are a few facial expressions for you to draw. Expressions can convey emotions, behaviours and intentions, for example happy, thoughtful or threatening, and add a sense of mood and character to a sketch, bringing it to life.

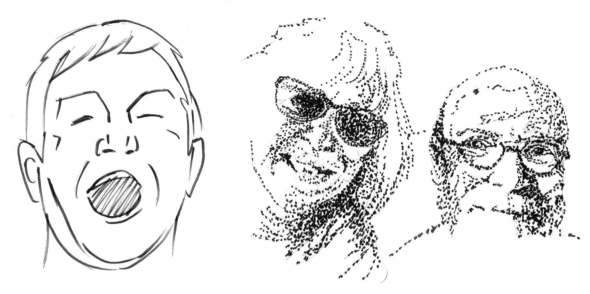

A *happy face* has a big smile with an open mouth that turns up at the corners, wrinkles around the eyes, raised cheeks, and eyes that are partially closed.

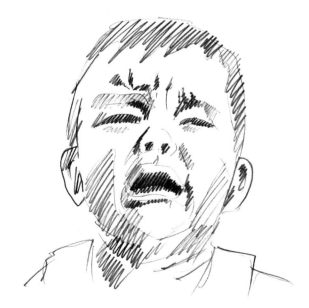

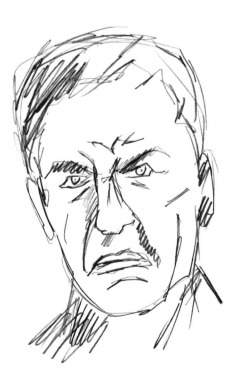

An *unhappy face* has a furrowed forehead and eyebrows, which may be raised in the middle. The face pinches in towards the centre and the lip corners are pulled down.

An *angry face* has a deep frown and furrowed V-shaped eyebrows which turn down and inwards towards a flared nose; a square tense mouth (open or closed); and narrowed eyes with an icy stare.

10-minute sketch: hands and feet

You can sketch hands and feet in a few minutes and if you're short of models, you can always draw your own! You'll soon become familiar with the shapes if you sketch hands and feet in different positions, even if the angles do seem a little odd at first. Once you apply a few details and tones, though, they instantly look better.

Try this selection of hands and gestures from people of different ages. Notice the plump features of the baby's hand compared to the more lined, rougher-skinned and characterful older hand.

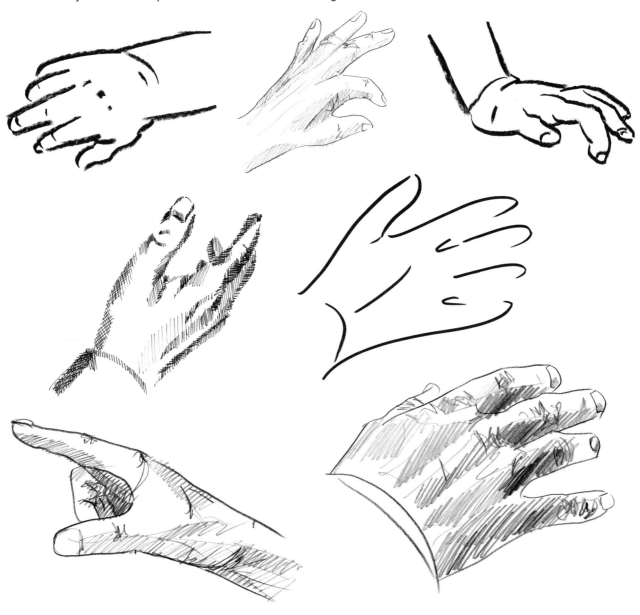

Left to right, top to bottom: Baby hand (charcoal); plucking female hand (HB pencil); child's hand (charcoal); reaching hand (fineliner pen); open hand (marker pen); pointing hand (HB pencil); older male hand (HB pencil).

You'll find that most of these feet can be sketched quite quickly. They include feet from the young and old, both with and without footwear. Have a go at sketching some without outlines, such as the gent's ankle and shoe.

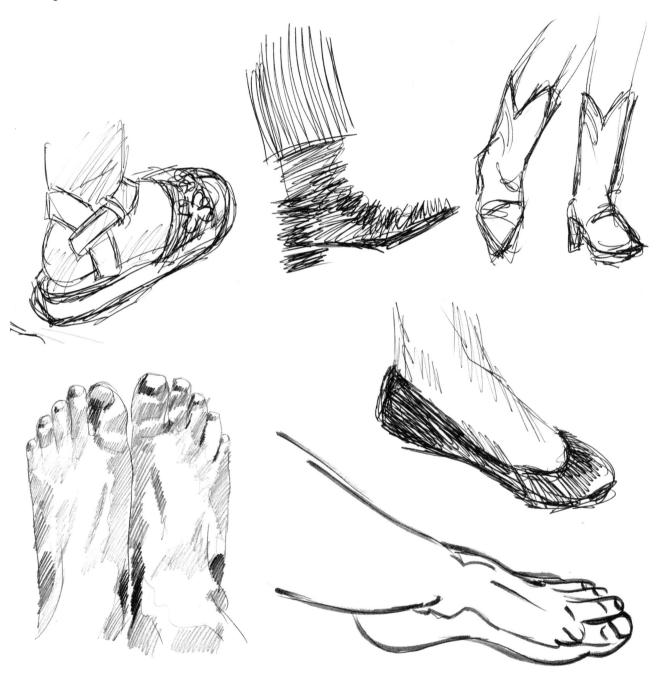

Left to right, top to bottom: Child's foot in a sandal (biro); male ankle and shoe (biro); women's boots (biro); pair of bare feet (HB pencil); bare foot (grey felt pen); female foot and shoe (biro).

Movement

As you've seen with animals, it can be a challenge to capture the impression of motion in a quick sketch unless you take a photograph to use later. Here are some examples for you to practise, starting with some easy stick people. Use loose lines to show action (the simplest option is mere outlines) and don't worry if your sketches are blurry or squiggly as this adds to the air of movement. Blind sketching is also good as you can keep your eye on the action while you sketch. Look for body language and energy, too; for example, are the people relaxed or animated?

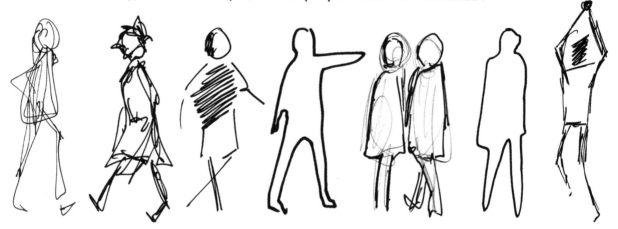

Quick ways to sketch people in motion (fountain pen).

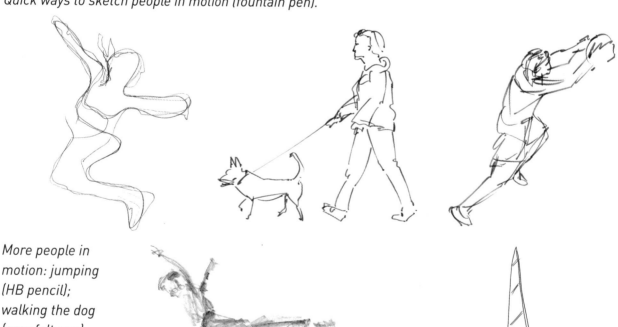

More people in motion: jumping (HB pencil); walking the dog (grey felt pen); goalkeeper (biro), ballet dancer (HB pencil); windsurfer (fineliner pen).

Groups of people

When sketching groups, look for overall movement: are they bunched together or spread out; are movements slow or rapid, even repetitive? If you're watching from a seated position you'll have more time to capture the scene. Your sketches may tell a story, for example a conversation, or they may create a sense of place or mood.

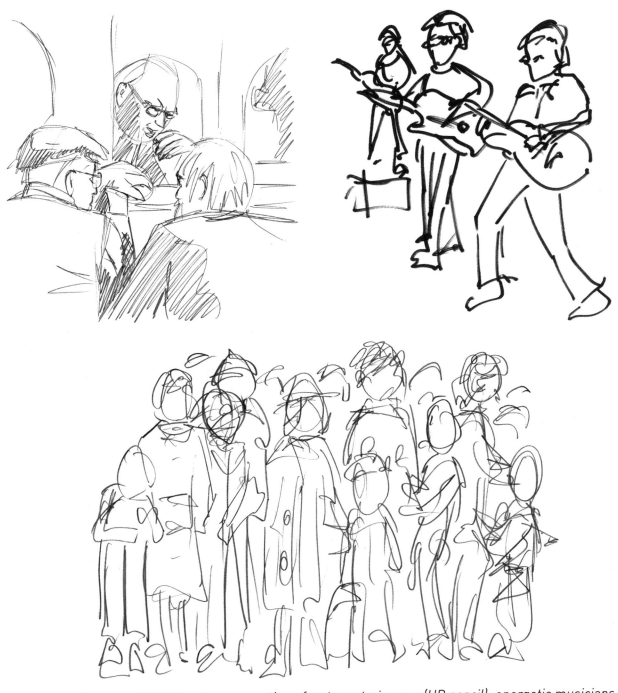

Clockwise from top left: intimate conversation of a steam train crew (HB pencil); energetic musicians on stage (marker pen); people queuing at an event (HB pencil).

Portraits

Now that you have acquired the basics of establishing proportions and rendering features in different ways, the next step is to sketch a familiar face, perhaps of a friend or family member, or even yourself. Self-portraits in particular are an excellent way to test your skills and learn about sketching.

At first glance you may wonder how to capture a likeness or demeanour on paper or what it is that gives a person their sense of vitality and uniqueness. A sketch can portray not just physical appearance but also the essence of personality and character. You can do this by applying the techniques you have learned so far about gauging proportions, using various media and so on and then add your own style, energy and interpretation to bring a portrait to life. Sketching portraits is very rewarding, especially if you capture the likeness.

BABY *(marker pen)*

Sketch this baby in marker pen with minimal strokes – a mere four or five are needed to describe each limb and even fewer strokes to depict each facial feature. There is just enough detail to convey this expressive subject; notice the plump limbs, the almost round head, and the barest suggestion of fingers and toes. You may find it helpful to establish the proportions first with faint guidelines.

TWO GIRLS *(HB pencil)*

If you cannot find subjects willing to pose, you can always work from a photograph. My sketch here is from a school photo showing two small girls sitting at a table with an open book; school photos taken by a professional photographer are very good quality and make a great substitute for working from life. Try this sketch, using simple outlines and diagonal strokes in medium and dark tones. Just a hint of background detail is needed on the chair backs.

Take care when sketching the girls' arms because the angles can be deceptive.

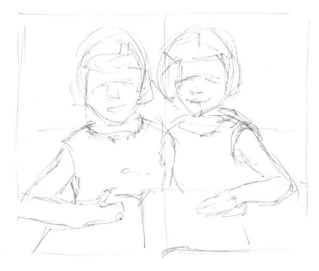

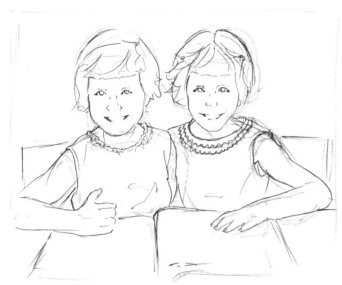

STEP 1

Outline the area of your work and, if needed, sketch some guidelines. For example, start with the larger shapes such as the chair backs, table edge and foreground book, noting the lines of perspective along the sides of the book.

STEP 2

Carefully adjust any features to achieve the required likeness, but don't overdo it! Only minimal and partial details are required on the face, for example, just the corners of the mouth are sufficient. Add clothing details such as the decorative necklines.

STEP 3

You can choose to leave this as a simple sketch, outline it in ink or add a few tones to add depth and volume.

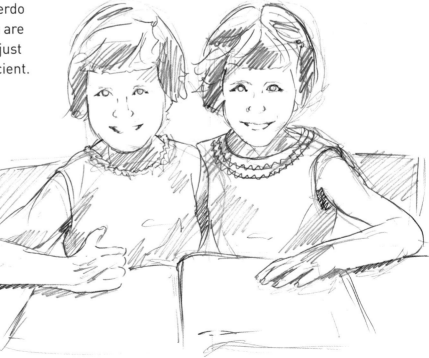

YOUNG WOMAN *(woodless graphite)*

This picture of a young woman is a little more detailed and is described in several steps to show you how to sketch the features. You can see how to create a realistic portrait using dark, medium and light tones once you've set out the proportions (use the guide on p.95).

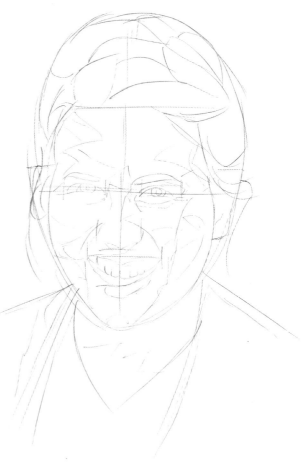

STEP 1

Look for the main shapes and tonal areas of the head, face and neck and sketch these as faint guidelines. Notice that most of the shapes on the face are geometric and blocky.

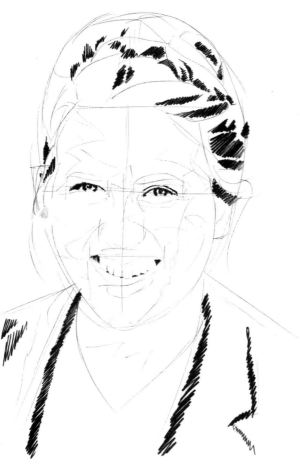

STEP 2

Lighten or erase guidelines if preferred (I chose to leave guidelines in place until the final step.) Use quick diagonal strokes to add the areas of darkest tone in the hair, lapels and eyes. Don't draw around all the teeth; a line underneath the top row is much more realistic.

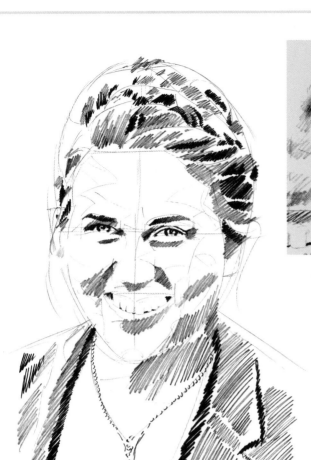

STEP 3
Add areas of medium
tones to the hair, face,
neck and jacket in the
same diagonal strokes
(see inset for detail).
Use small, curved
strokes for the necklace.

STEP 4
Erase any unwanted lines.
Finally, add light tones to
the brow, cheeks and neck,
remembering to leave areas
of highlight blank.

YOUNG MAN IN THE STYLE OF RAPHAEL
(HB pencil)

Raffaello Sanzio da Urbino, known as Raphael (1483–1520), was considered to be one of the great masters of the High Renaissance period, along with fellow Italians Michelangelo and Leonardo da Vinci. This sketch was inspired by his *Portrait of a Youth* (1499), which may have been a self-portrait. I have chosen it because of its construction from simple lines and tones. Volume, or form, is achieved with a mix of light and dark strokes and the very closely spaced darker lines which create deeper areas of shadow. In Raphael's sketch, which you can find on the internet, it's interesting to note how some lines fade from dark to light along their length, for example the hair coming out from under the cap.

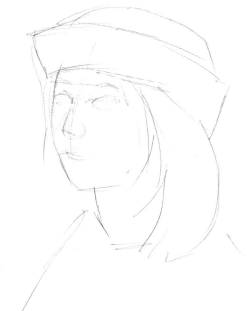

STEP 1
Begin by drawing faint guidelines to establish the correct proportions.

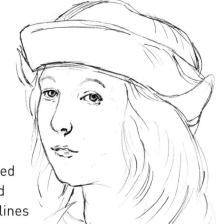

STEP 2
Erase unwanted guidelines and darken some lines to emphasize the facial features, cap and hair.

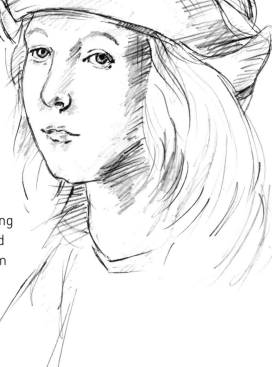

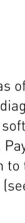

STEP 3
Add areas of tone by sketching parallel diagonal strokes and areas of soft, light to medium shading. Pay particular attention to the eye features (see inset).

Older women

Using the skills you've practised, quickly sketch these examples of women of varying ages in different media. As before, begin by setting out the proportions and add any guidelines you feel are necessary. Alternatively, you can draw them as an outline or even a blind sketch. When sketching the faces of older people, you will need to accentuate the features, for example by adding expression lines (such as laughter lines) and shadows and shading. In this way you can add individual character to a face. The same features on a younger face will be less prominent because there are fewer lines and shadows.

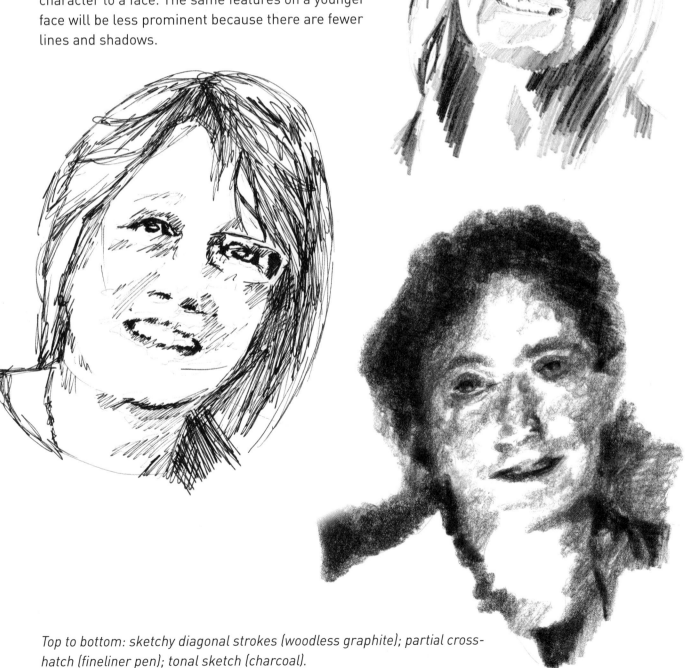

Top to bottom: sketchy diagonal strokes (woodless graphite); partial cross-hatch (fineliner pen); tonal sketch (charcoal).

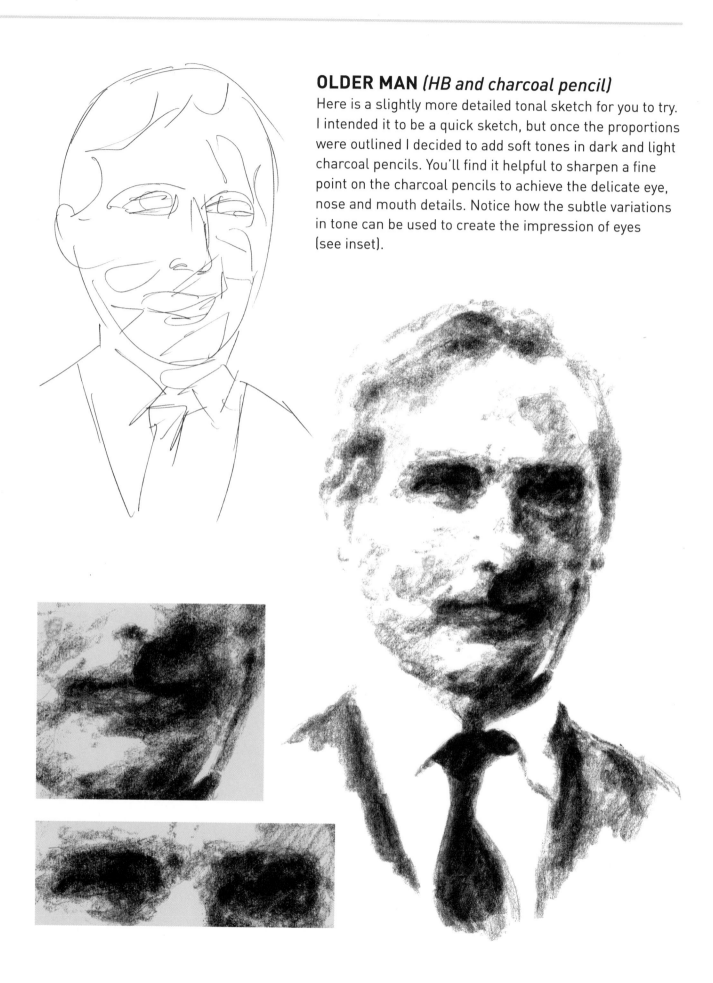

OLDER MAN *(HB and charcoal pencil)*

Here is a slightly more detailed tonal sketch for you to try. I intended it to be a quick sketch, but once the proportions were outlined I decided to add soft tones in dark and light charcoal pencils. You'll find it helpful to sharpen a fine point on the charcoal pencils to achieve the delicate eye, nose and mouth details. Notice how the subtle variations in tone can be used to create the impression of eyes (see inset).

Common errors

Incorrect proportions

Facial features can be difficult to portray accurately and if you focus on features such as the eyes and mouth they can become disproportionately large, as in this over-sentimental example (right). To overcome this, study the head proportions and lightly sketch the main elements first to check they are correct.

The woman walking her dog (below) has a disproportionately large head compared to her body. To correct this, use the rough guide of seven to eight head lengths in the body.

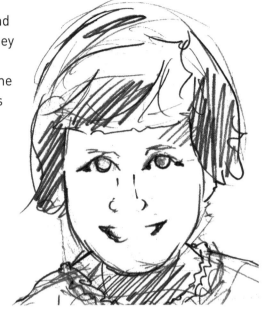

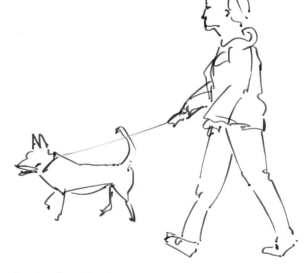

Lack of context

The dog appears to be walking in mid-air! It would help if there was a hint of ground surface.

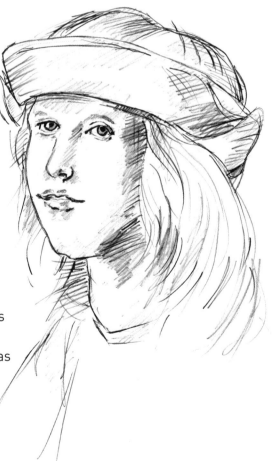

Alignment of facial features

A head sketched at an angle often has more of the features visible than would be the case, like the youth's mouth in this example. Always sketch guidelines to ensure the features are the same angle as the rest of the face. Also, eyes are often placed too high up the head, instead of at the mid-line.

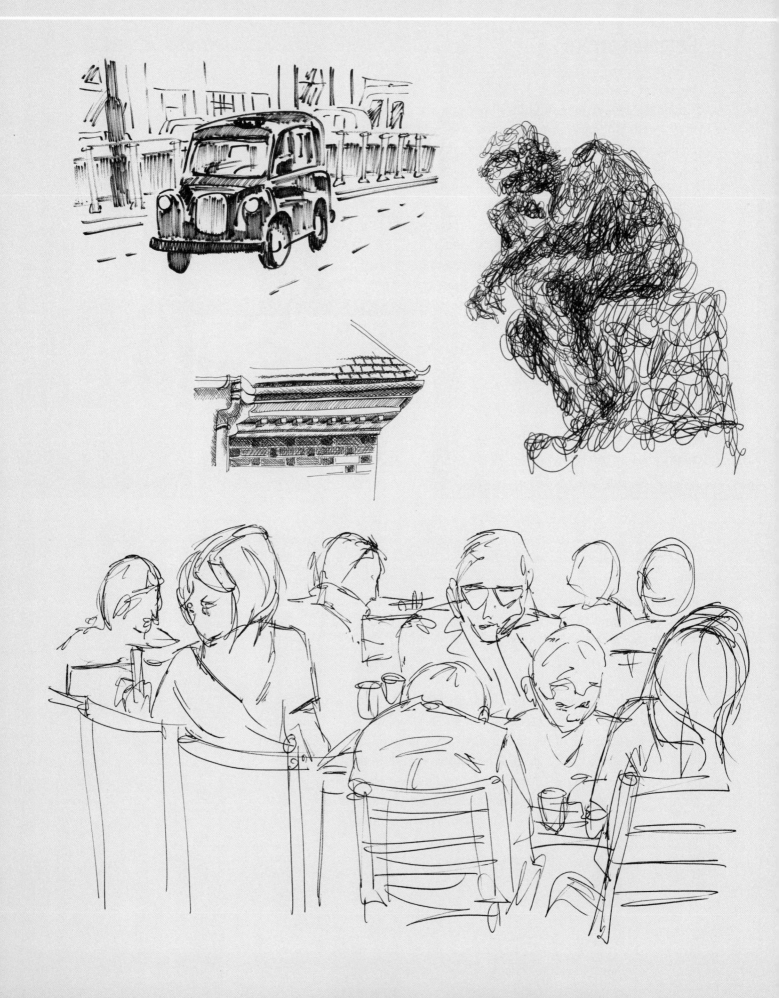

Chapter 6

URBAN SKETCHING

This chapter builds on everything you've learnt and brings together most of the elements you've practised so far. We'll look at things to sketch in urban surroundings, beginning with smaller, uncomplicated examples. You may live in a town or city you know very well, but sometimes we see familiar places or things differently when we start to sketch and look at them in a new light. The idea is not to draw everything you see in detail but to keep things simple and loose, to represent your ideas of what you see and capture any first impressions or moods, however fleeting. You'll see how to create effects for urban subjects with different media such as bold, expressive charcoal and marker pen, the precise marks of pen and ink or the more delicate hues of pencil and graphite.

Once you've stepped on to the street, the first thing to do is to look around for anything that catches your eye. Your sketches can take minutes or hours to complete and be in any medium. If you find yourself stuck for ideas, make yourself comfortable, for example in a café, and practise the basics or blind sketches and the ideas will soon flow. Sketching can be surprisingly sociable as people around you may be curious about your work! But keep safely aware of your surroundings – sketching is very absorbing and it's easy to become so involved in telling a story about your experiences on location that all other considerations are set aside. The aim is to come home happy and fulfilled, with a collection of exciting sketches that record your day.

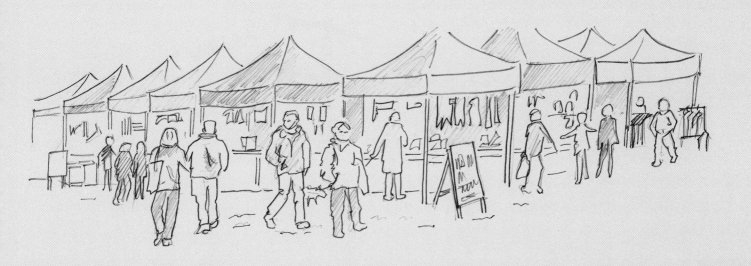

Skylines

When you're faced with a complex scene full of detail, begin with simpler elements before attempting to sketch everything before you. To get you started, here are some straightforward contours of city skylines to sketch in different media – can you guess where they are? (The answers are at the bottom of the page.)

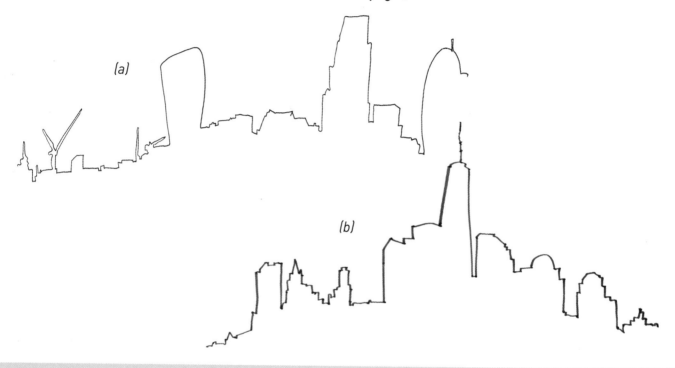

(a)

(b)

10-minute sketch: telegraph wires

This is another sketch with simple shapes and lines that you can do quickly in any medium. Utility poles and wires are common features in urban landscapes, and the wires make convenient bird perches. The silhouetted features really suit the bold strokes of a marker pen.

Street scenes

Urban streets usually have buildings on both sides, and the architecture will reflect the culture and function of the area: shops and restaurants in the centre, office blocks and industrial buildings in commercial districts and homes in residential neighbourhoods. In smaller towns, streets will probably have a mixture of all these.

Whatever you sketch, your street scenes will come to life and tell more of a story if you add people to them. To refresh your memory of drawing figures, sketch these examples of strollers and shoppers. I used HB pencil and fineliner pen.

Begin with outlines and ensure your shapes match human proportions. Look for interesting poses, such as this man reading a paper, someone in a doorway looking into a bag and a photographer snapping passing marathon runners.

STREET CAFÉ *(biro)*

Cafés and restaurants are great places to sit and watch the world go by. They also provide a wonderful opportunity to tell a story when you sketch different poses and the body language of people nearby, such as these diners sitting outside a café. No guidelines were used in this speedy biro sketch; have a go at capturing people without any planning yourself.

Practise sketching with minimal strokes to capture basic details, such as this mini pencil sketch of three people under the awning of a street café.

Be prepared for unexpected encounters and to sketch on the go. I sketched this street busker, pavement planter and statue quickly with no preliminary marks.

BUSKER *(marker pen)*
Use bold, minimal strokes to record a musician in action.

PLANTER *(grey felt pen)*
Outline the tubs first, then sketch the leaves and flowers in clumps of different shapes, rather than random scribbles. Add small patches of very dark tones between the leaves to add realism. Use layers of diagonal strokes to create the shadows on the tubs.

STATUE *(biro)*
Scribble the light and dark patches by varying the density of the strokes. It's easy to correct the proportions as you go. To help gauge proportions, use the rule of thumb (see p.38), half-close your eyes, or close one eye entirely.

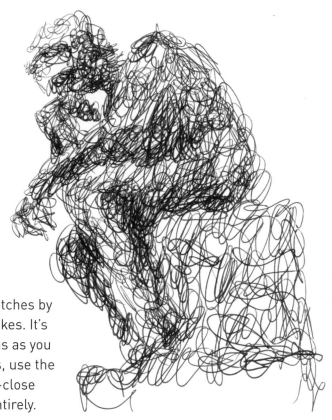

ALLEYWAY *(biro)*

Look for unexpected views as you're walking along – a glance down this alleyway revealed a sunlit scene of houses and vegetation with a mountain backdrop. The dark passageway through the buildings framed the view and contrasted beautifully with the bright scene beyond. The illusion of linear perspective is achieved by the angled lines of the passageway appearing to converge at a vanishing point, then enhanced by the overlapping buildings.

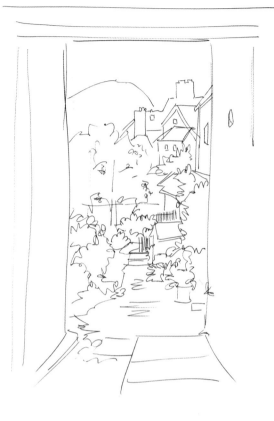

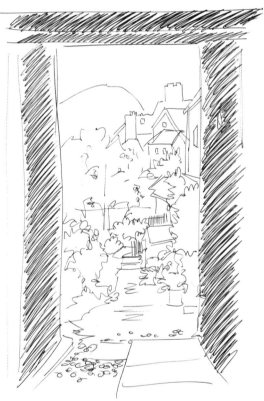

Use outlines to define the layers of buildings, shrubs and trees that line a path to the distant fence and beyond. Note how the taller houses in the background suggest a hilly slope. Use a single curved line for the mountain. No shading is needed except for the alleyway, with dark, diagonal strokes for the tunnel-like passageway between two buildings.

Experiment and compare different shading directions in a part of your drawing or on scrap paper to see which works best, for example, vertical, horizontal and perspective. Sometimes, it's easiest to keep things simple (plain diagonal strokes).

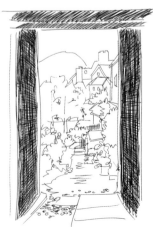

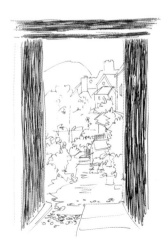

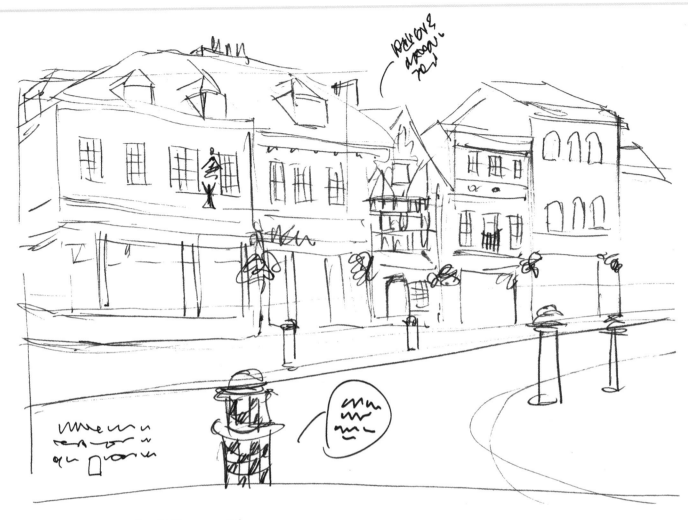

THE OLD TOWN *(HB pencil)*

Some streets are interesting because of their architecture, such as this row of historic town-centre buildings. If you feel overwhelmed by a complex scene, remember that you're sketching an impression and you don't have to indicate every brick. Here, all the rows of windows are drawn but an alternative is to sketch one window in a row in more detail and use simple lines for the remainder of the row, or even depict them as just outlines. If you want to highlight a particular feature, spend time on recording extra detail and/or add notes to your sketch.

Roof detail (cross-hatch) and lamp (pointillist style) both in fountain pen.

CITY STREET
(grey felt pen)

Draw the impression of city workers and tall concrete and steel buildings in this uncomplicated sketch using blocks of tone (mostly circles and rectangles). Begin by making soft circles and shapes at the bottom of the sketch to represent the moving crowd, starting with the nearest heads, making them smaller as they move into the distance. Leave spaces between the people

to create the impression of light. Use rough lines of perspective to help you block in the buildings, windows, and awning feature in different tones.

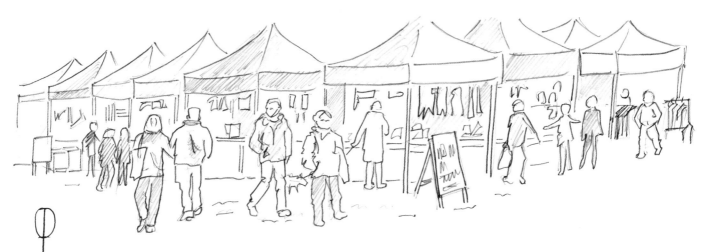

Left: simple scale to sketch people.

MARKET DAY *(HB pencil)*

Now try this pencil sketch of an outdoor street market, brought alive by people. Draw figures in different styles, shapes and sizes (see p.100 for ideas) and if you find sketching their proportions difficult, this simple scale is very useful (remember that an adult body is roughly seven or eight times the height of the head). Add pale shading to market stall canopies and a few people – there's no need to shade everything.

Buildings

Most urban landscapes contain buildings of historic and architectural interest and some also contain modern buildings of ground-breaking design. These examples show how easy it is to portray key features in just a few minutes.

10-minute sketch

DECORATIVE PORCH *(HB pencil)*

Capture the striking circular wrought ironwork and glass panels of this unusual and decorative porch, adorned with hanging baskets. Outline the overall shapes of the porch roof and supporting columns, then identify the main elements of the wrought iron patterns (here it is overlapping circles) and sketch them in simply. You can indicate the hanging baskets with some light scribbly marks.

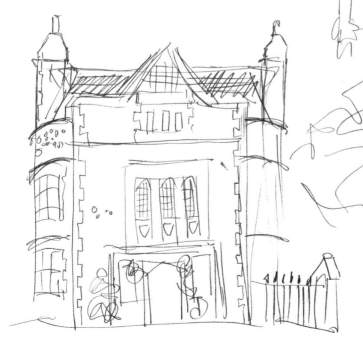

MUSEUM *(HB pencil)*

For a challenge, sketch this old building with strokes that are minimal yet still capture the bay windows, quoined walls and arrow-topped railings.

CATHEDRAL *(fineliner pen)*

This more detailed scene is viewed through the arching leafy branches of trees either side of the path to the main door, the branches almost mimicking the cathedral architecture. The lines of perspective along the path lead your eye towards the main door. You won't be able to sketch everything on such a large building, so focus on the main features. While on location you can always add mini sketches of specific features, for example detailed stonework and patterning.

To re-create this scene, begin with the branches and leaves, then sketch the main shapes of the cathedral and shade sparingly. Add the people last, referring to the sketches of people in movement on page 100. Remember to use linear perspective and to diminish the size of the people in the distance. Note how they also add scale to your sketch.

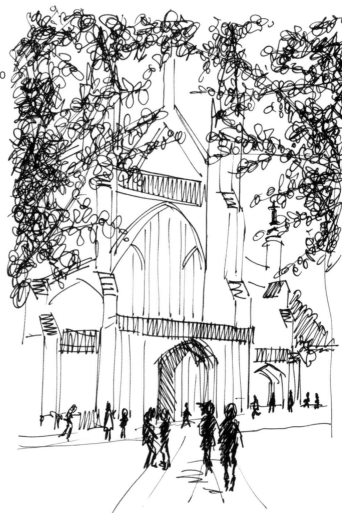

THE GHERKIN *(HB pencil)*

This is one of London's most recognizable towers, 30 St Mary Axe, otherwise known as the Gherkin because of its distinctive shape. Create this scene with simple geometric shapes and blocks of tone.

STEP 1

Outline the main shape of the Gherkin with its bullet-like top, then add mostly rectangular shapes of various sizes and orientation for the surrounding buildings.

STEP 2

Add two closely spaced curved lines around the circumference of the Gherkin near the top, then draw a regularly spaced diamond-shaped latticework of lines, following the curved surface of the building.

STEP 3

Fill in the top few diamond shapes with dark tones and then every third stripe leading down from the top of the building. Add a few small blocks of dark tone to some of the surrounding buildings to denote windows.

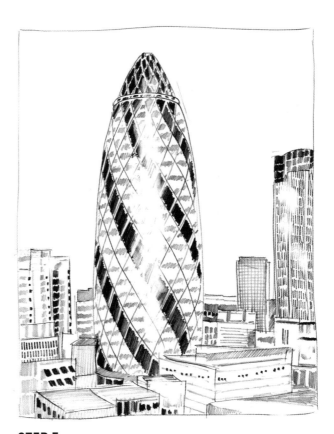

STEP 4

In medium tones, add small blocks of zigzag strokes to each of the remaining diamond shapes on the Gherkin. In the same tone, add more details to the surrounding buildings such as simple lines, grids and blocks to depict windows and other structures.

STEP 5

Finally, erase a few areas on the Gherkin and other buildings to create the impression of highlights and the effect of light glinting off the shiny structures.

Transport and journeys

The various forms of transport in our towns and cities are themselves interesting to draw, from skateboards and bicycles to taxis, buses and trains. Journeys on public transport, even time spent waiting, can provide exciting opportunities for you to sketch. Here are some ideas to inspire you as you go out and about.

SKATEBOARD *(HB pencil)*

To start off, try this study of a skateboard, sketched here in pencil. The subject size is relatively small, so you shouldn't find this too daunting.

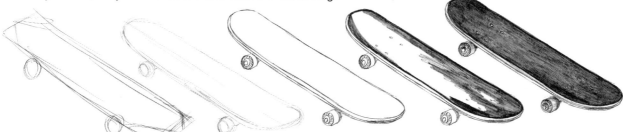

STEP 1

Identify the main shapes (a rectangular board and two visible circular wheels).

STEP 2

Lightly refine the outline, using a centre line to help achieve the rounded ends and overall shape.

STEP 3

Define the outline more strongly and erase unwanted marks.

STEP 4

Begin to fill in the tones, using a line of dark tone around the outside of the board. Add the two groups of four ellipse-shaped fasteners which secure the wheels to the board.

STEP 5

Fill the board (avoiding the fasteners) with smooth medium/dark tones.

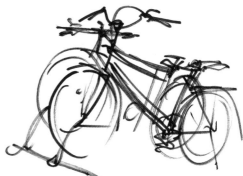

CYCLIST *(HB pencil)*

Have a go at sketching a cyclist in motion. The aim is to record an impression without much detail. Use wide and soft horizontal zigzag strokes behind the cyclist to imply features in the background and vehicles passing the other way. These blurry strokes also emphasize the cyclist's speed.

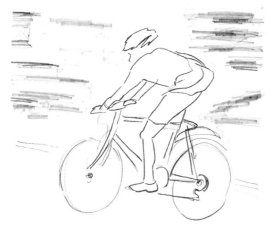

BICYCLES IN A RACK *(marker pen)*

Bicycles can appear complicated, so start with bold, sweeping strokes to portray the key characteristics of the circular wheels and geometric frames and leave the rest of the detail to the imagination.

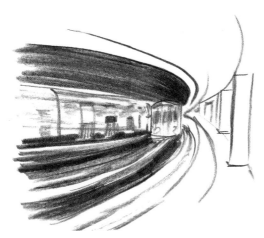

THE UNDERGROUND *(charcoal)*

Quickly sketch an impression of the underground, perhaps while you're just waiting for a train. Few details are needed but linear perspective is crucial. The train on the left is rendered in lines of sweeping charcoal and this, combined with the stark contrast between the darkness of the track and tunnel and the bright lights on the platform, creates a sense of drama and emphasizes the speeding blur of the moving train. The more detailed, less blurry train on the right suggests much slower movement. If you are sketching at a station above ground, the perspective of the train tracks will be just as important, but you will not see so much contrast between light and dark.

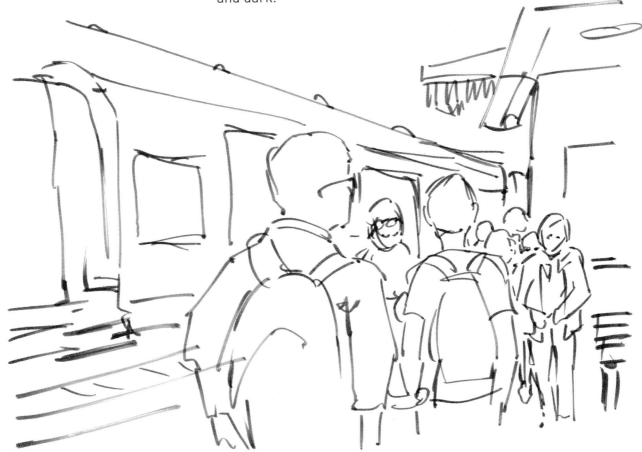

ON THE PLATFORM *(grey felt pen)*

Use loose outlines to sketch the main elements quickly without putting much thought into them. We all make mistakes when working at speed to capture a moment (see how the platform edge is drawn through the man's left arm!) Set out the lines of perspective using the train roof line, platform edge and building guttering. Add the people, starting with those closest to you, noting they become smaller further along the platform. As before, more detailed elements can be drawn separately.

Station clock and telephone sign (biro).

ON THE TRAIN
(woodless graphite)

Train journeys provide interesting chances to sketch, although the frequency of stops and rocking motion of some trains will hinder accurate drawing in fine detail. At the risk of wonky results, use bold lines and blocks of sketchy strokes to portray your fellow travellers. Pay attention to perspective and the proportions of people, visualizing the hands of a clock to estimate any unusual limb angles.

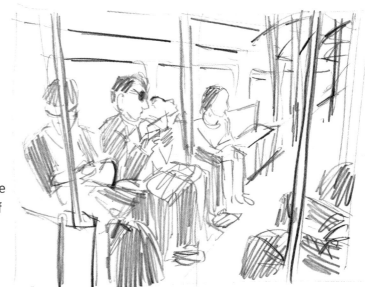

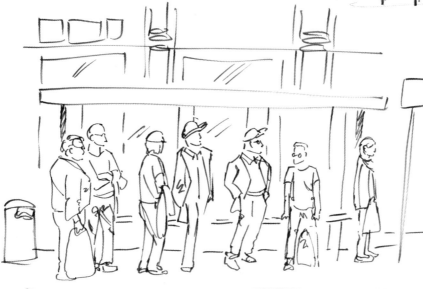

BUS STOP (grey felt pen)

Test your observation and story-telling skills by sketching a queue at a bus stop. You'll be surprised at how much information you can convey with a few lines. For example, the postures tell you that most of these people are looking the same way, so you could imagine they are looking for the next bus.

TAXI (marker pen)

Moving vehicles are a challenge, but taxis in many cities look alike and are seen repeatedly, so you have a better chance to record those on paper. For this London black cab, focus on the overall shapes such as the rounded body panels and grille, headlights and wheels, then roughly shade, leaving spaces to denote highlights.

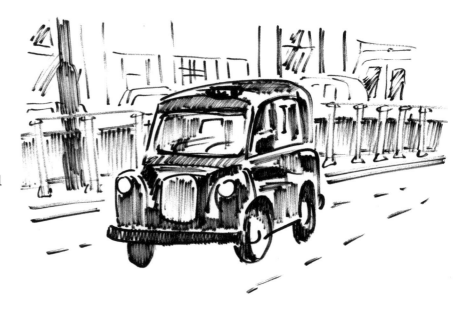

TRUCK *(biro)*

Experiment with a different medium to capture the impression of a large truck. Simple outlines are sufficient to convey the large geometric features.

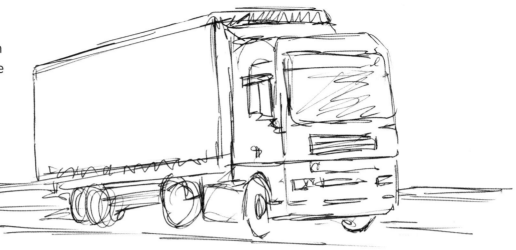

CLASSIC CAR *(woodless graphite)*

Motor car technology has evolved considerably over time, but the basic car shape has remained relatively unchanged – a metal box on wheels with a concealed engine. This vintage Wolseley from a bygone age sports simple, elegant lines.

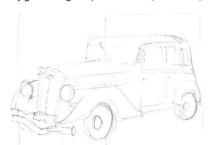

STEP 1

Outline the boundary of your work and divide it into four to help you gauge proportions and angles. Lightly sketch the main features. Vehicles can appear complex, so simplify what you see, focusing on overall shapes. While I used woodless graphite, other media are equally well-suited to a drawing of a car.

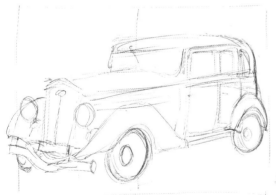

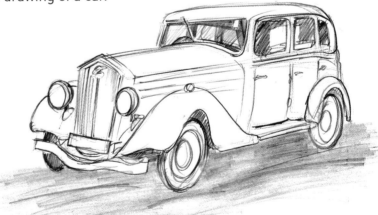

STEP 2

Check and refine details, including lines of perspective (for example I adjusted the windscreen angle, wheel size and bodywork lines along the side). Define details more clearly and then erase unwanted marks.

STEP 3

Make final adjustments, strengthen lines, then add details and shading or leave as an outline sketch. Use the flat side of a pencil or woodless graphite to create the soft, broad strokes of the ground surface.

The changing seasons

Urban landscapes look very different as the seasons roll round, since each one heralds different weather, fashions and behaviour.

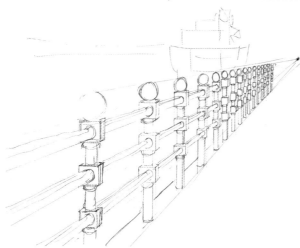

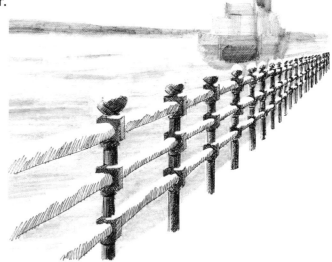

WINTER SNOW *(fineliner pen, woodless graphite)*

Mixed media is ideal to portray this wintry dockside scene. Use pen and ink to create the stark contrast between the hard black rails and soft white snow and graphite for the out-of-focus background ferry, sea and shoreline. To construct the elaborate railings, first set out the lines of perspective, then locate the light source (from the left). Carefully cross-hatch the rail details, completing the background last and leaving the snowy areas blank.

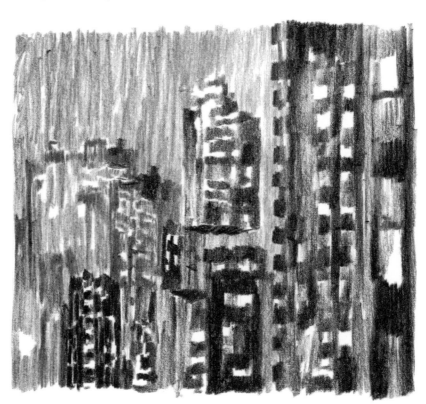

RAINY NIGHT *(charcoal)*

Sketch this city nightscape viewed through a rain-streaked window in fuzzy, streaky, rectangular blocks of graphite. Leave the lit windows blank or pale and use varying light, medium and dark tones to represent the different buildings and features.

10-minute sketch: summer in the park

Use a wide or flat HB pencil lead and pale shades in impressionist style to create the illusion of a hazy sunny day.

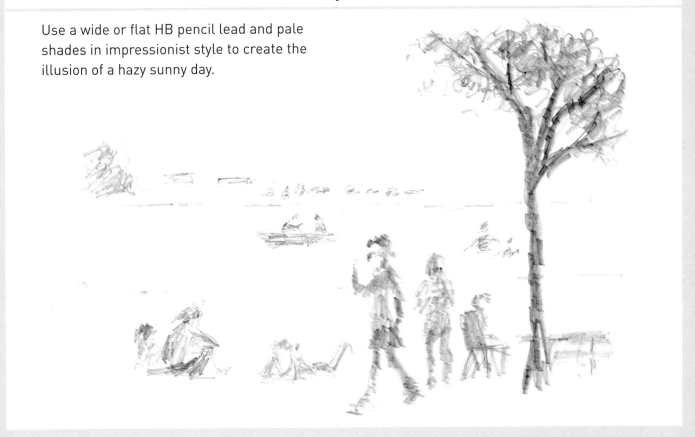

Summary

I hope you have enjoyed your sketching journey from first marks to detailed scenes, tackling the challenges you were set along the way. You've seen how easy it is to sketch, even blindly, and how it is possible to sketch in even brief moments here and there.

Take pleasure in your improving sketches as you practise. If you get stuck, simply start with easy exercises to get warmed up and the ideas and inspiration will soon return. Don't forget to date and sign your sketches and keep them safe on your travels. You can store loose sketches between the leaves of a sketchbook or use clear plastic pockets in a folder or clip file, depending on where you are and how much space you have when travelling.

One of the many joys of sketching is that you'll begin to be much more observant about the world around you, noting seasons and subjects that spark your desire to draw. With growing confidence, you'll discover that you can sketch anything, anywhere, at any time, assembling a portfolio of work that will give you pleasure long after it was made.

Index

aerial perspective 33

alleyways 116

animals 70–89

aquatic animals 74–5

atmospheric perspective 33

babies 102

bicycles 122

birds 76–7

blind sketches 25, 45, 61, 76, 93, 96, 100

bottles 30

box shapes 25–7, 31

buses 124

bushes 59

cafés 114

Caravaggio 39, 41–2

cars 125

Cézanne, Paul 39

chairs 45–6

children 103

circles 28

composite shapes 17

composition 20, 24, 34

Constable, John 62, 64

cross-hatching 16

ellipses 28

erasers 12

expressions 97

faces 94–6, 97, 109

farm animals 78–81

feet 99

flowers 43–4

fruit 39–41

Gainsborough, Thomas 64

gardens 56–8

glass 30

glasses 28

group portraits 101

hands 98

heads 94–6

historic buildings 117, 119–21

interiors 47–8

keys 29

landmarks 61

landscapes 50–69

Leonardo da Vinci 6, 43, 106

linear perspective 33–7, 69

lines 14–15, 21

markets 118

materials 10–13

Michelangelo 6, 106

Monet, Claude 43

motion 88, 100, 122

mountains 59, 63

mugs 19

negative shapes 17, 46, 66, 84, 96

older people 107, 108

one-point perspective 33, 35

outlines 49

paintbrush 13

paper 11

pencils 10

pens 10

perspective 32, 33–7, 47, 48, 69

pets 82–5

planters 115

portraits 90–109

postures 92

proportions 38, 94–5, 109

Raphael 106

rural landscapes 64

seasons 126–7

shading 15–16, 31

shadows 31, 32, 49

shapes 17, 21, 25–30, 31

sharpeners 12

sitting or standing 20

skateboards 122

skylines 62, 112

skyscapes 62

small animals 73

statues 115

still life 24–30, 39–46

street scenes 113–18

suburbs 54

taxis 124

teapot and teaspoon 29

three-point perspective 34, 37

tin cans 32

townscapes 110–27

trains 123–4

transport 122–5

trees 59–60, 66–8

trucks 125

two-point perspective 33, 36

Van Gogh, Vincent 6, 24, 43, 48, 64, 65

vanishing point 32, 33

vegetation 59–60

volume 18

Wainwright, Alfred 63

water in landscape 65–8

wild animals 86–7

young people 104–5, 106

POOR PERSPECTIVE: SPOT THE DIFFERENCE (PAGE 69)

The areas of the drawing indicated (left) do not follow the lines of perspective (right).

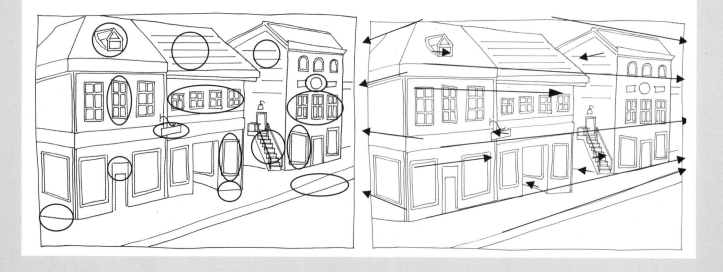